Beyond the Return of Religion: Art and the Postsecular

Brill Research Perspectives in Religion and the Arts

Editor-in-Chief

Diane Apostolos-Cappadona (*Georgetown University*)

Associate Editors

Barbara Baert (*University of Leuven*)
S. Brent Plate (*Hamilton College, New York*)
Zhange Ni (*Virginia Tech*)

Volumes published in this Brill Research Perspectives title are listed at *brill.com/rpra*

Beyond the Return of Religion: Art and the Postsecular

By

Lieke Wijnia

BRILL

LEIDEN | BOSTON

This paperback book edition is simultaneously published as issue 2.3 (2018) of *Brill Research Perspectives in Religion and the Arts*, DOI:10.1163/24688878-12340005.

Library of Congress Control Number: 2019906411

Typeface for the Latin, Greek, and Cyrillic scripts: "Brill". See and download: brill.com/brill-typeface.

ISBN 978-90-04-41170-8 (paperback)
ISBN 978-90-04-41174-6 (e-book)

Copyright 2019 by Lieke Wijnia. Published by Koninklijke Brill NV, Leiden, The Netherlands.
Koninklijke Brill NV incorporates the imprints Brill, Brill Hes & De Graaf, Brill Nijhoff, Brill Rodopi, Brill Sense, Hotei Publishing, mentis Verlag, Verlag Ferdinand Schöningh and Wilhelm Fink Verlag.
Koninklijke Brill NV reserves the right to protect the publication against unauthorized use and to authorize dissemination by means of offprints, legitimate photocopies, microform editions, reprints, translations, and secondary information sources, such as abstracting and indexing services including databases. Requests for commercial re-use, use of parts of the publication, and/or translations must be addressed to Koninklijke Brill NV.

This book is printed on acid-free paper and produced in a sustainable manner.

Contents

Beyond the Return of Religion: Art and the Postsecular 1
 Lieke Wijnia
 Abstract 1
 Keywords 1
 1 Introduction 2
 1.1 *Visibility of Religion* 2
 1.2 *The Return Narrative* 5
 1.3 *Approaching the Postsecular in the Arts* 9
 1.4 *Outline* 12
 2 Secularization 15
 2.1 *The Secular as Default* 16
 2.2 *Enchantment* 24
 3 Diversification 30
 3.1 *Translation and Its Strategies* 32
 3.1.1 Reformulation 35
 3.1.2 Ludification 37
 3.1.3 Re-presentation 41
 3.2 *Liquid Boundaries* 43
 3.3 *Alternative Imaginaries* 48
 4 Spiritualization 53
 4.1 *Acknowledging the Spiritual in Art* 54
 4.2 *Art as Spiritual Alternative to Religion* 62
 4.3 *Spiritual Engagement with Art* 66
 5 Concluding Perspectives 73
 5.1 *One Dutch Fall* 74
 5.2 *The Postsecular Is Work in Progress* 78
 5.3 *The Postsecular Exists through Negotiations* 79
 5.4 *The Postsecular Is a Public Affair* 80
 5.5 *The Postsecular Defies the Religion-Secular Binary* 80
 Acknowledgements 82
 Bibliography 83

Beyond the Return of Religion: Art and the Postsecular

Lieke Wijnia
Museum Catharijneconvent, Utrecht, and University of Groningen, The Netherlands
l.wijnia@catharijneconvent.nl

Abstract

Beyond the Return of Religion: Art and the Postsecular explores the conceptual potential of the postsecular for investigations of (late) modern art and religion. Indicating a public co-existence and merging of religion and the secular, the postsecular is approached as an alternative to the return of religion narrative. Rather than framing artistic concerns with religion as a recurrence after temporary absence, it is argued how the postsecular allows for seeing the interaction between art and religion as enduring, albeit transforming relationship of mutual nature. Whereas secularization theories are intrinsically connected to modernity, the postsecular requires a pluralized perspective, covering the processes of secularization, diversification, and spiritualization. The postsecular reinforces the interconnectedness of these processes, which are, in turn, embodied in the concept's interdisciplinary nature. While this essay predominantly focuses on visual art and its institutional context of the museum, the postsecular has interdisciplinary relevance for broader artistic and academic disciplines.

Keywords

postsecular – secularization – spirituality – diversity – art history – art museums – late modernity – modern art – contemporary art

∴

For Erik

∵

1 Introduction

Throughout the twentieth-century study of modern and contemporary art, the most dominant critical narrative was that of secularization. Even though terms like 'secular' or 'non-religious' may not be directly applied to art objects or artists themselves, art historical categories have been largely shaped in concordance with secularization theory. This bore assumptions of a so-thought proper, neatly framed, and often invisible, place of religion in artistic practices, musealization, and critical reception of the works of art. While in the study of fine or high art, religion and spirituality is generally treated as a neatly boxed category, the study of that which is called folk, naïve, outsider, and primitive art is usually exuberant with historicized or exoticized portrayals of religion. While during the last decades scholarship has increasingly demonstrated how many modern artists made work strongly rooted in religious or spiritual convictions, in most studies religion still takes up a conspicuous position. Rather than being presented as a fundamental category of, on the one hand, the life worlds of the artists and their works, and, on the other hand, the critical scholarly framework, religion continues to be approached as a category that can be isolated or even ignored in the understanding of artworks.

Through the following, this essay will posit the conceptual framework of the postsecular as a significant tool to further scholarly efforts in the acknowledgement of religion's foundational and pluriform presence in modern and contemporary art. Some readers may feel I am too optimistic about the conceptual potential of the postsecular. Yet, as I hope to argue throughout this text, the reasons why the concept has emerged and the potential roads of enquiry it presents cannot be ignored just yet. Despite its highly debated nature, the notion of the postsecular offers a way of moving scholarship beyond the dominant conception of a return of religion, which seems to haunt academic and public discourse. The generally popular observation that religion was gone for several decades in the twentieth century, but has returned in the late twentieth- and especially in the early twenty-first century is historically inaccurate and too inattentive towards the nuances and varieties of religion's manifestations in artistic practices throughout modernity.

1.1 *Visibility of Religion*
An initial attempt to explore the implications of the postsecular for the study of the arts was the 2017 symposium *Art in a Postsecular Age* at Biola University.[1]

[1] The symposium was organized by the Center for Christianity, Culture, and the Arts, Biola University, La Mirada, CA., 4 March 2017. The video registration of the symposium can be found online: http://ccca.biola.edu/resources/2017/mar/6/art-postsecular-age/.

The symposium not only featured theologians, but also artists, art historians, and art critics.[2] In his introduction to the event, Jonathan Anderson was the first to admit to the contested nature of the postsecular, while simultaneously positioning it amidst numerous recent developments in the field of religion and the arts. He described how over the past two decades, the dominance of secularization theory has been compromised. Scholars increasingly attest to how modernization processes have not led to a decrease, or even disappearance, of religion in the Western public sphere. Even though the societal and cultural position of its institutions are strongly transforming, alternative formations of religion joined the traditional institutions on the public stage. Like in other societal domains, these developments had a large impact on the field of the arts and its institutions. Anderson described three phenomena to illustrate this impact.

First, religion has a visible presence in the production of contemporary art. Artists like Theaster Gates, Kris Martin, and Mark Wallinger work with explicit religious themes and imagery in their practice. This art, in turn, receives prominent public presence. For the prestigious Fourth Plinth commission for London's Trafalgar Square, Wallinger placed his sculpture of a life-size Christ figure with bound hands behind his back and a head crowned with gold-colored barbed wire. Titled *Ecce Homo*, this sculpture first appeared in public on Trafalgar Square in 1999, for the duration of the Fourth Plinth commission, and was later placed on the west steps of St. Paul's Cathedral in 2017. Its placement at St. Paul's was not only a Cathedral initiative for the purpose of Holy Week celebrations. Rather, it occurred in partnership with human rights organization Amnesty International and was presented as an occasion to reflect upon—and call for action regarding—contemporary injustice, torture, and suppression, just as much as on the figure's Christian implications.

Second, artists are commissioned to make new work in response to religious sites and are invited to create lasting contributions to liturgical spaces. Prominent examples are Anthony Gormley's *Sound II* (1986) in Winchester Cathedral; Tracy Emin's *For You* (2003) in Liverpool Cathedral; Gerhard Richter's window (2007) for the Dom in Cologne; Anish Kapoor's *Ascension* (2011) in the San Giorgio Maggiore, Venice; Bill Viola's *Martyrs (Earth, Air, Fire, Water)* (2014) in St. Paul's Cathedral, London; Xu Bing's *Phoenix* (2014) in St. John the Divine,

2 Biola University has an Evangelical Christian signature. During the symposium there was an interesting discrepancy between speakers that argued for a necessary inclusion of theological discourse in public debates about art and religion, and those who sought for a (non-theo)logical and informative place for religion in the study and criticism of art. The parts I reference in this work predominantly reflect to the latter type of contributions, in which theology has a place in the postsecular understanding of art, but is not a fundamental prerequisite.

New York City; and, more recently, David Hockney's *The Queen's Window* (2018) was unveiled in Westminster Abbey, London. These commissions contribute a contemporary, reflective dimension to the religious spaces in which they are installed, appealing to art audiences that may not necessarily visit the sites otherwise, and demonstrate that contemporary artists find inspiration in sacred sites, their histories, and traditions.

Third, art museums have staged, and are staging, large exhibitions with themes on religion in general, religious figures, or religious artists. Much-cited examples are *100 Artists see God* at the Laguna Art Museum and Institute of Contemporary Art, London (2004–2005); *Traces du Sacrée* [*Traces of the Sacred*] in Centre Pompidou, Paris (2008); *Heilig Vuur* [*Holy Fire*] in the Nieuwe Kerk in Amsterdam, with the collection of the Stedelijk Museum that was then closed for renovation (2008); and *The Problem of God* in K21, Düsseldorf (2015–2016). All these recent endeavors are presented as following in the footsteps of what is regarded as the grandmother of exhibitions on religion in modern art, *The Spiritual in Art: Abstract Painting 1890–1985*, organized by the Los Angeles County Museum of Art and the Gemeentemuseum in The Hague (1986–1987).

It is notable how two of these described developments relate to institutional settings. The contexts of commission and display are important features to this essay's exploration of the postsecular, because the situatedness of visual art in museums—and artistic practices in institutional settings in general—are crucial to the postsecular as an analytical instrument. Religion and art do not exist in secluded, isolated places of artist studios and the private homes of collectors. Instead, the dynamics between religion and art consist of a variety of forms, manifestations, and encounters in both private and public domains. Its manifestations both represent and shape how individuals and collectives experience and interpret religion and the arts.

The contemporary public presence of religion raises a set of significant questions, offering the groundwork for the relevance of the notion of the postsecular. How to characterize the omnipresence of religion in public institutions like art museums? How to make sense of the dynamic between religion and art in public sites, which equally exist to represent its visitors, respond to popular demand, and to educate about the unknown, misunderstood, and underrepresented? And what is the position of artists within this dynamic relationship between religion, artworks, and public institutions? Do they respond to contemporary complexities, envision and present unthreaded territory, or walk their own private spiritual paths, which are translated into their works of art?

The three developments, as described by Anderson at the 2017 symposium, underline religion's visibility in the contemporary art world, both in artistic

practices and in institutional settings. The visibility of religion simultaneously invites and demands discussion, opening up avenues for public reflection and debate. However, in order to be studied to their full extent, these developments also demand a reorganized analytical toolbox—to which this essay's explorations of the postsecular hope to modestly contribute.

1.2 *The Return Narrative*

Crucial to the academic understanding of the position of art in the twentieth and twenty-first centuries is the religion-secular binary, providing a lens through which religion is positioned in a sphere of its own, while the secular is used as characterization of the visual art world at large. Scholarly positioning of artistic practices in late modernity generally has this pairing of opposites at its heart. Consequentially, this has led to a long-dominant and ever-persistent frame of religion having returned to the artistic stage—and western societies at large—after a period of absence.

This notion of, as it will be referred to throughout this essay, the 'return narrative' is grounded in narratives of secularization, which have flourished in a variety of manifestations ever since the early modern period in the western world.[3] Not only in the domains of politics, governance, and academia,[4] but just as much in the broader understanding of the role and function of creative and artistic expression in societal configurations. According to Maria Hlavajova, Sven Lütticken, and Jill Winder, in the introduction to their seminal reader *The Return of Religion and Other Myths: A Critical Reader in Contemporary Art*, the return narrative "is in large part constructed by the circulation in the mass media of certain *images* (i.e. the headscarf, the Danish cartoons of Mohammed, or the Twin Towers being hit by a plane) and through attacks against such images on religious grounds."[5] This reader resulted from a research and exhibition project exploring the construction of the return of religion, a project that "is something else than merely the discovery of a topical topic that in the end remains external to art; [rather] it is an attempt to think religion with and through art."[6]

3 Herman Paul. 2017. *Secularisatie: Een Kleine Geschiedenis van een Groot Verhaal* [Secularization: A Small History of a Large Narrative] (Amsterdam: Amsterdam University Press).
4 Matthew Sharpe and Dylan Nickelson (eds.). 2014. *Secularisations and their Debates. Perspectives on the Return of Religion in the Contemporary West* (Dordrecht: Springer).
5 Maria Hlavajova, Sven Lütticken, and Jill Winder. 2009. "Introduction" in Maria Hlavajova, Sven Lütticken, and Jill Winder (eds.). *The Return of Religion and Other Myths. A Critical Reader in Contemporary Art* (Utrecht, Rotterdam: Bak, Post-Editions) 8.
6 Idem," 10.

As this quote reflects, the return narrative frames the understanding of (at least) two aspects in relation to the arts: the academic study and employment of critical approaches to the arts, and in the production of artworks themselves.[7] It is not my aim here to trace the development of the mode of thinking that resulted in a return narrative in art historical research, albeit a great endeavor that I would happily reserve for another occasion. Yet, it is of interest to this essay to look at some attempts that declare this mode of thinking in terms of a return narrative unhelpful and challenge its premises.

Particularly relevant is Sally Promey's 2003 article "The 'Return' of Religion in the Scholarship of American Art." Focusing on modern American art, Promey observes how in the second half of the twentieth century scholars, and art historians particularly, were not concerned with religion, did not think to describe artistic subject matter in terms of religion, and museums rarely organized exhibitions of modern religious art. One of the article's main premises is that these art historical tendencies do not automatically imply that artists were not concerned with religion to begin with. Promey identifies the secularization theory of modernity as one of the root causes why academics long did not have an eye for religion in their studies of modern art. Because, as secularization narratives argue, if an increasingly modernizing world is intricately connected to the disappearance of religion, then in increasingly modernizing art there should be less and less room for aesthetic expression of the spiritual. One of the key strategies, Promey argues, in the dominant presence of the secularization narrative in art history is the analytical approach of formalism.

Disregarding the historical contexts, cultural connotations, and social realities in which an artwork was produced or presented, formalism as an analytical strategy constitutes a technique of secularization. Formalism's origins can be traced back to Immanuel Kant's *The Critique of Judgment*[8] and was later developed by modernist art historians, notably Clement Greenberg.[9] For Kant, form is the spatial arrangement of figures, lines, and shapes, which in turn is at the heart of beauty. Potential meaning or symbolic references of constellations of these figures, lines or shapes is of no importance here. Promey coincides this deliberate ignoring of potential religious or spiritual significance with another important tendency in modern art history: 'The ascension of formal-

[7] The interest in the return narrative is not only apparent in the field of visual arts, but also in other disciplines. E.g. John A. McClure. 1997. "Post-Secular Culture: The Return of Religion in Contemporary Theory and Literature," *CrossCurrents* 47.3: 332–347; Andreas Andreopoulos. 2000. "The Return of Religion in Contemporary Music," *Literature and Theology* 14.1: 81–95.
[8] Immanuel Kant. 1987 (1790). *The Critique of Judgment* (Hackett Publishing: Indianapolis).
[9] Clement Greenberg. 1989 (1961). "Avant-Garde and Kitsch" in Clement Greenberg, *Art and Culture, Critical Essays* (Boston: Beacon Press) 3–21.

ist approaches in the scholarship and criticism of art, furthermore, coincided with an inclination to define religion in institutional terms and to discern its pictorial presence principally in iconography or subject matter.'[10] This parallel emergence of both a blind and reductionist eye has strongly impacted the place of religion in art historical scholarship.

It, again, does not at all mean that artists were not concerned with religion and the spiritual. Hence, the 'return' of religion in art seems to primarily refer to the scholarship on art rather than artistic production itself. As Promey formulates it towards the end of her article, "The art historical 'return' to the study of religion that I document and endorse is not a mere recuperation but a return with a difference. It does not simply pick up a set of concerns once explored and then put aside. It involves, instead, a resituation of religion in scholarly conversation."[11]

While Promey's article is concerned with the place of religion in art historical scholarship, artistic practices themselves are central to the above-mentioned reader *The Return of Religion and Other Myths*. The editors approach the return of religion from two angles. On the one hand there is a continuance of inspiration that religion—its iconography, stories, and traditions—offers to artists, while, on the other hand, there is a strong late-modern presence of religious fundamentalism and its persistent attack on religious imagery, artworks, and visually adorned sites of worship. The tension between this pluriform presence of religion in, and impact on, contemporary art informs the majority of the book's contributions.

The title of the reader rings a similar tone of skepticism as in the title of Promey's article, which placed the word return between quotation marks. By identifying the return of religion in art as a myth, its enduring presence is reinforced. Although an exact definition of myth is lacking, the term emphasizes the constructed, often repeated, yet hardly substantiated character of the return narrative. Even more so, because the reader's varied contributions about the pluriform relationship between art and religion demonstrates its enduring, albeit transformed, nature. In his contribution to the reader, Kenan Malik calls the return of religion "as illusory as was the death of God in the first place. God is no more alive now as he was dead then. Rather the very meaning of religion has changed."[12] Malik ties this transformation of meaning to a weakened faith

10 Sally Promey. 2003. "The 'Return' of Religion in the Scholarship of American Art," *The Art Bulletin* 85.3: 588
11 Idem, 596.
12 Kenan Malik. 2009. "The God Wars in Perspective" in Maria Hlavajova, Sven Lütticken, and Jill Winder (eds.). *The Return of Religion and Other Myths. A Critical Reader in Contemporary Art* (Utrecht, Rotterdam: Bak, Post-Editions) 119.

in human-directed progress, without necessarily a return to traditional institutional conceptions of divine power. Simultaneously, religion is reorienting towards individualized notions of well being and belonging. This leads Malik to observe how, "over the past two decades, [western societies have] become less secular without becoming more religious."[13]

The reader's dual characterization of religion's presence in art in terms of iconoclasm and inspiration provides a relevant departure point in positioning late modern dynamics between art and religion in a postsecular framework. Despite such pronounced critical efforts of challenging and overturning the narrative about the return of religion in art, this narrative remains persistent and strong in both popular opinion and the manners in which academics frame and conduct their research. This also occurs in the use and legitimizing of the notion of the postsecular. In his book *Partial Faiths: Postsecular Fiction in the Age of Pynchon and Morrison,* John McClure lists several reasons for characterizing literature as postsecular,

> because the stories it tells trace the turn of secular-minded characters *back* toward the religious; because its ontological signature is a religiously inflected disruption of secular constructions of the real; and because its ideological signature is the rearticulation of a dramatically 'weakened' religiosity with secular, progressive values and projects.[14]

These characterizations are all informed by a conception of the return of religion. Overall, with terms such as 'return' and 're-enchantment,' thinkers, journalists, and scholars alike attempt to claim a 'religious turn' in the perception of the public sphere, of which artistic practices are an important part.

In the spring of 2018, Dutch journalist Yvonne Zonderop published a book titled *Ongelofelijk* [*Unbelievable*].[15] The title relates to both the notion of religious belief and the perceived nature of religion's public presence in the ever so secular Netherlands. The subtitle of the book, 'about the surprising comeback of religion,' indicates how this publication uses the frame of the return narrative. And successfully so, as following the publication of the book Zonderop has been frequently invited as public speaker at a variety of events. Notably, she was the keynote at the opening of the 2018 academic year at the

13 Idem, 127; 120.
14 McClure, John. 2007. *Partial Faiths: Postsecular Fiction in the Age of Pynchon and Morrison* (Athens, GA: University of Georgia Press) 3. Emphasis added.
15 Zonderop, Yvonne. 2018. *Ongelofelijk: Over de Verrassende Comeback van Religie* [Unbelievable: About the Surprising Comeback of Religion] (Amsterdam: Prometheus).

Protestant Theological University in Groningen. Additionally, the theme of the 2018 annual Night of Theology was *God is Back*. As if God would have ever disappeared from, out of all places, the field of theology.

Another remarkable impact of this publication was of visual nature. The book's cover photograph, of a church interior repurposed into a skateboarding hall, was used on the cover of a report of the Central Bureau for Statistics (CBS) about the state of religion in The Netherlands. As Zonderop claims that the surprising comeback of religion predominantly happens outside of traditional institutional contexts, the CBS report stated that for the first time in the history of the Netherlands, a majority of Dutch citizens (51%) are unaffiliated with religious institutions.[16] The report's equation of being religious and an affiliation with religious institutions is of a highly problematic nature, which in turn unleashed a public debate in the newspapers and magazines about the challenges of defining, and thus researching, religion.

In its aim to refute the general observation underlying theories of the secularization of modernity—increasing modernity equals decreasing religiosity—the use of the return narrative actually embraces secularization narratives. Return narratives endorse the dominant idea that throughout the nineteenth and twentieth centuries religion was disappearing from the public space, including museums and artistic production all together. In the use of terminology such as 'surprising comeback,' the twenty-first century is characterized as manifestly different from the preceding centuries. The above-described publications, which attempt to make sense of the diverse and persistent presence of religion in late modern artistic practices, its production, display, and representation, demonstrates how the template of the return narrative still has a topical character and how it is used in a variety of ways.

However, the return narrative's underlying dynamics of opposition to, and contrast between, are not the most fruitful ones in actually reaching a better understanding of the relationship between modern art and religion. Therefore, what I aim to offer is an attempt to formulate an alternative narrative based on the question: What would happen if the notions of 'return' and 'opposition' are temporarily sidelined? If the art-religion relationship is framed as a continued co-existence? Into an enduring and transforming dynamic of mutuality?

1.3 *Approaching the Postsecular in the Arts*

During the 2017 Biola University symposium, most of the contributors agreed that the return of religion narrative is insufficient to analyze the presence and

16 Hans Schmeets. 2018. *Wie is religieus en wie niet?* [Who is religious and who is not?]. Report Centraal Bureau voor de Statistiek [Central Bureau for Statistics].

visibility of religion in modern and contemporary art. For Lori Branch, the postsecular offers an alternative. She began her paper presentation with the acknowledgement of the multiple ways in which the postsecular is used, and a specification of what she means by this term. Mentioning designations of the postsecular of theological,[17] political,[18] historical,[19] and philosophical[20] natures, Branch described her approach as a postsecular state of the humanities. To her, the postsecular entails "a critical perspective on the secularization thesis and on secularism as an ideology, and all the things that the critical perspective, the distance from secularism, and the secularization thesis, opens up."[21]

In her introduction, she also admitted to the personal nature of her talk, which, she simultaneously argued, is very appropriate for the nature of scholarship on the postsecular. "If there is something like a postsecular, if there is something like a postsecularity, then it is very present. And it is something that we are performing and making as we go." Such statements underline how the postsecular is currently best regarded as a field in development, a response to an academic—and societal—need, which makes it a challenging and exciting topic to work on. Predominantly, the postsecular embodies the urge for an alternative narrative to secularization theories, one that reinforces the complexities of the contemporary interrelationship between religion and the secular.[22]

In addition to its widespread and at times conflicting use, one discomfort with the postsecular lies in the prefix 'post.' As if this implies that the secular public sphere, and with that the separation of church and state, is no longer a given sacred in democratic societies. However, the 'post' in postsecular seems to be of a different nature than the 'post' used in the general scholarly trend to indicate the end of one era and beginning of a new one by means of the prefix 'post' (post-industrialization, post-colonialism, post-modernism, post-museum, post-truth etc.). As Arie Molendijk observed, "the claim that the

17 Phillip Blond (ed.). 1998. *Post-secular Philosophy: Between Philosophy and Theology* (Abingdon: Routledge).
18 Jürgen Habermas. 2008. "Notes on Post-Secular Society," *New Perspectives Quarterly*. Fall: 17–29.
19 McClure, *Partial Faiths*.
20 Hent de Vries. 1999. *Philosophy and the Turn to Religion* (Baltimore: The Johns Hopkins University Press).
21 Lori Branch. 2017. "What is Postsecularity?," Symposium *Art in a Postsecular Age*, Center for Christianity, Culture, and the Arts, Biola University, La Mirada, CA., 4 March. http://ccca.biola.edu/resources/2017/mar/6/art-postsecular-age/.
22 Benjamin Schewel. 1997. *Seven Ways of Looking at Religion* (New Haven: Yale University Press) 6–7.

'secular age' has been overcome does not figure very prominently among proponents of 'the postsecular.'"[23]

In relation to the arts, it is most useful to approach the postsecular for, as Branch describes it, the critical distance it allows. This critical distance invites the construction of the perception of a public sphere in which religion and the secular co-exist, meet, and potentially merge in a variety of public domains, such as education, politics, media, and, indeed, the arts. As Molendijk formulates it, the postsecular "stands for the attempt to understand the position and role of religion in late modernity in a way that overcomes the idea that 'religion' is basically a premodern phenomenon which will disappear in the long run."[24] As called for by several scholars at the 2017 symposium, this attempt is particularly much needed in scholarship on the arts.

The field of artistic practices is often used as an example to illustrate the relevance of the postsecular. In his much-cited presidential address at the 2010 meeting of the Society for the Scientific Study of Religion,[25] James Beckford describes the arts as one of the six core clusters of the postsecular. He calls this cluster 'Reenchantment of Culture' and states that it "revolves around the idea that creative and artistic sensibilities are moving away from secular themes to explore a realm of enchantment and magic. It is about making imaginative leaps from the secular to the postsecular."[26] In his response article to this presidential address, Molendijk reformulates the categorization of Beckford's core clusters but the arts remain in an unchanged cluster of its own.[27]

Beckford predominantly lists a variety of authors who make 'dramatic claims' about the unique nature of the 'sacred turn' in artistic production that denounces strict secularist assumptions—and in doing so, he largely denounces, or least strongly questions, the legitimacy of these claims.[28] In citing the same authors as Beckford, Molendijk rather focuses on the described character of the art works themselves. He observes that postsecularity in arts is described as "the capacity to disclose transcendence in ways beyond the great traditional religions."[29] While Beckford analyzes the use of the postsecular as ill-defined and at times even contradictory in the many academic fields it is used in,

23 Arie L. Molendijk. 2011. "In Pursuit of the Postsecular," *International Journal of Philosophy and Theology.* 76.2: 101.
24 Idem.
25 James A. Beckford. 2012. "SSSR Presidential Address: Public Religions and the postsecular: Critical Reflections," *Journal for the Scientific Study of Religion* 51.1: 1–19.
26 Beckford, *Public Religions and the postsecular*, 6
27 Molendijk, *In Pursuit of the Postsecular*, 102–103.
28 Beckford, *Public Religions and the postsecular*, 6
29 Molendijk, *In Pursuit of the Postsecular*, 102.

Molendijk reinforces the practical relevance of the term in further developing the understanding of contemporary phenomena which have "the 'intertwinement' of the secular and the religious"[30] at their heart. This intertwinement, so Molendijk argues, is based on one of the fundamental binaries with which humans understand their worlds: the religion-secular binary.

In line with Molendijk's approach that invites for stronger empirical research, and the questions set out by the participants of the 2017 "Art in a Postsecular Age" symposium, this work provides an exploration of how to think about the modern and late-modern art through the lens of the postsecular. The main questions asked are: How do the two terms relate to one another? What does it mean to say 'postsecular art,' if that can be said at all? Does the postsecular refer to a moment in the history of ideas, which would mean we would talk about art in relation to postsecular thought? Is it a characteristic of the work of art, resulting in the phrasing 'the postsecular in art'? Or do we speak of a postsecular condition, to which the arts respond and which they actively shape? As this essay will demonstrate, all these approaches are viable options, depending on the selected argumentative route. For one, at this stage, it shows the variety of usage and perceived applicability of the term—about which, of course, Beckford made an important argument in his presidential address. However, this is not a reason to discard of the term completely. Rather, I see it as an invitation for precision of the formulation of the term's implications and explore its relevance in working towards a better understanding of the dynamic between art and religion in (late) modernity.

1.4 Outline

As such, this essay positions the postsecular as a relevant narrative in response to questioned dominance of secularization narratives, and its impact on the art world and the discipline of art history. Serving as a basis for approaching the phenomenon of the omnipresence of religion in the arts, the postsecular opens up a pathway in which there is room for a variety of societal and cultural trends at once. Secularization theory is intricately bound up to the overall process of modernization, leading to causal interpretations about the differentiation, privatization, and disappearance of religion.[31] In contrast, I propose to

30 Molendijk, *In Pursuit of the Postsecular*, 110.
31 Cf. José Casanova, *Public religions in the Modern World* (Chicago, London: University of Chicago Press, 1994). According to Casanova, secularization theories emphasize three core-processes: secularization as social differentiation; as disappearance of religion; and as privatization of religion. While, for Casanova, and in post-secular thought in general, the first element of social differentiation is beyond doubt, the second of disappearance and third of privatization are up for discussion and in need of empirical research.

root the conceptual framework of the postsecular directly into several societal processes, which allows for a more complex understanding of the pluriform presence of religion in modern and contemporary art worlds. These processes are: 'secularization,' 'diversification,' and 'spiritualization'—and more importantly, their interconnectedness. The essay chapters are structured along the lines of these three processes.

Chapter 2 deals with secularization, the dominant narrative pattern through which the position of religion in the modern world is understood— and to which the framework of the postsecular is a response. The chapter first explores how art production, display, and scholarship are rooted in secular convictions. Secular self-identification has long determined—and to a certain extent still determines—the place of religion in the discipline of art history and in art museum practices as often strictly defined and contained. The postsecular no longer allows for such containment of religion, searching for new routes of inquiry of understanding the pluriform intertwinement between religion and the secular. One such approach, which has been long part of debates about secularization, is constituted by the notion of enchantment. Its counterparts of dis- and re-enchantment are usually employed to indicate the dis- and re-appearance of religion in the arts. The notion of enchantment explores the power of images, characterized in terms of religiosity and spirituality, in both artistic practices and how viewers engage with works of art.

A theoretical approach like that of enchantment allows for a much broader and diverse understanding of what art and religion are, and can be. Chapter 3 explores the process of 'diversification' and its implications for the art world where religious and secular eyes meet and merge into new constellations. In the creation of such new constellations processes of translation take place, from one domain to the other, and for new audiences. A more varied audience also means new strategies of finding relevance of religious heritage, as a lack of knowledge is often the cause for indifference or even misunderstanding. This occurs especially when religious imagery is artistically processed in provocative or challenging manners. Offense has become a recurrent feature in religiously diverse societies. Diversity in terms of ethnic, national, and religious identities ideally requires appropriate representation and incorporation in public institutions. Museums are increasingly aware of the need to have a diversity policy, oriented at both the visitors they serve and the ways they approach and display their collections. While there is a wide range of religious art from a wide range of religious and spiritual traditions to choose from, I chose to focus on one of the most topical issues. Within the context of Europe, especially Islamic museum collections are taken out of the depositories and collection displays get makeovers to reflect more inclusive approaches to the

museum collections. Also, participation programs around such initiatives are organized for (religious) minorities who do not necessarily find their way to the museum. In response to the diversifying constellation of the communities around them, museums are facing the challenge to create room for new religious imaginaries in their often traditionally Christian-rooted institutions.

Increasing (non)religious diversity—and the diversity of artistic and museum practices this results in—coincides with the rise of new religious movements and practices. This is why Chapter 4 explores the significance of 'spiritualization' for a postsecular understanding of art and religion. Throughout the twentieth century, a growing awareness of the spiritual nature of much modern art was formulated. This has led to a continuous redefining of the presence of religion and the spiritual in modern art, and the question of whether new forms of spirituality have emerged through the meeting and merging of religion and the secular. Additionally, in the late eighteenth century, art has gained a spiritual status of its own, independent of—and parallel to—institutional religious frameworks. Art is often framed as an alternative for religion, or even a secular form of religion. Art seems to fulfill a desire for transcendence, in places and contexts where religious institutions may not deliver that promise. Many temporary exhibitions deal with the modern artistic interest in esoteric and spiritual movements. Engagement with visual art is capable of serving a spiritual need, for artists and audiences alike. As such, the artwork is positioned as a mediator, for it has the capability to connect religious pasts and presents. The spiritual convictions of an artist or particular religious tradition can be transmitted and, albeit in a transformed way, experienced in the present. For a contemporary, individualized and spiritually seeking audience, this may serve a very different purpose from how the work of art was originally intended—but, it still serves a spiritual purpose. This transformation process stands parallel to the one described in Chapter 3 as translation, and plays a key role in a postsecular understanding of art and religion.

The concluding part of the essay offers perspectives into future roads of enquiry in the construction and use of the postsecular perspective in the study of art and religion. Chapter 5 presents several observations to be taken from this essay's exploration of the postsecular, ranging from the usage of the term postsecular in relation to the arts, to how various scholarly disciplines can inform one another given the interdisciplinary nature of the postsecular; and from how the postsecular emerges through ongoing negotiations, to how the postsecular needs to defy the religion-secular binary.

Given the scope of the *Brill Research Perspectives* series, and the fact that this edition is an endeavor of a single author, the resulting text in front of you cannot aim for completion and definitive answers. Rather, as it is rooted in my

particular scholarly expertise and academic interests, this work predominantly explores the significance of the postsecular for modern and contemporary visual art, and equally so from institutional settings like museums, biennales, and galleries in the western world. This has led me to address the question whether the postsecular is a western, or even European, oriented notion, but cannot hide the fact that my expertise is not of global nature. As such, I hope this essay, resulting from an accepted invitation, will also become an extended invitation: to further explore artistic examples from a broader range around the globe, with more extensive attention to a variety of artistic disciplines and religious traditions. Even though multiple media are addressed where possible, the major focus remains on visual arts.

2 Secularization

Although the postsecular embodies a critical approach to secularization theories of modernity, this critical distance does not deny the process of secularization as such. The 'post' does not consider the secular as a foregone situation, it rather acknowledges secularization—and its societal impact—to be one of the fundamental roots of understanding the (late) modern relationship between religion and the arts. The postsecular recognizes the simultaneous presence of secularization and the pluriform manifestation of religion as a vital area of public concern.

This chapter explores two features of secularization's multi-dimensional relevance to the theoretical framework of the postsecular. First, it analyzes the origins and implications of seeing art production and its institutional displays and study as secular practices. The prevalence of secular (self)identification of artistic practices and its institutional contexts has led to classifications of religion as contained and strictly defined. The postsecular perception of arts and its institutions, however, no longer allow for a strictly defined categorization of religion and the secular.

Second, many scholars explore the notion of enchantment as a result of observations of the category-defying presence of religion in the context of artistic and museum practices, and visual culture at large. Enchantment, and its counterparts of re- and dis-enchantment, is strongly linked to the study of secularization. However, contrary to popular ideas about dis-enchantment, this is not the same as secularization. Despite its transformed appearances, the longing for enchantment remains ever strong in the modern world. Artistic practices are generally regarded to be a key field that is able to provide experiences of enchantment.

2.1 The Secular as Default

Much scholarship on modern and contemporary art and religion is based on its presumed opposition, or, at the very least, its complex interrelationship. The complexities of art and religion are often framed in response to secularization theory, presenting a variety of artistic practices in which religion and spirituality have a place. The predicted decline of religious presence is proven wrong, with the narrative framework discussed in the previous chapter, that of a 'return' or 'comeback' of religion. Even publications with a less tidy line of argumentation, are often still based on an oppositional pairing of art and religion, in which art reflects a set of practices rooted in secular understandings. This is reflected in publication titles, for example when religion is designated a 'strange' place in contemporary art, when art and religion are described as 'reluctant' partners, or when contemporary artists working on catholic imaginaries are characterized as 'postmodern heretics.'[32]

James Elkins's *On the Strange Place of Religion in Contemporary Art* is a relevant example. Through interactions with young contemporary artists, he traces how they talk about religion in their work, and parallel to that, how art historical scholarship discusses religion in its analytical approaches. It leads him to the observation of a paradox: "the art world can accept a wide range of 'religious' art by people who hate religion, by people who are deeply uncertain about it, by the disgruntled and the disaffected and the skeptical, but there is no place for artists who express straightforward, ordinarily religious faith."[33]

The book demonstrates how the analytical frameworks of art history do not allow for religious speech, thought, or visual vocabulary to come through with any kind of directness or clarity in the critical process. On the one hand this is because the analytical categories are rooted in secular thought—providing religion very narrow and strictly defined territories—while on the other hand the sociological orientation of scholarship is suspicious of that which cannot be observed or formulated outright. As such, Elkins reinforces Sally Promey's 2003 article, in which she argues how the distance between scholarship and practice needs to be closed, if art historical scholarship is ever going to find an integrated way of understanding the place of religion in the arts.[34] As Elkins

32 James Elkins. 2004. *On the Strange Place of Religion in Contemporary Art* (New York, London: Routledge); Ena Giurescu Heller (ed.). 2004. *Reluctant Partners: Art and Religion in Dialogue* (New York: The Gallery at the American Bible Society); Eleanor Hearney. 2004. *Postmodern Heretics: The Catholic Imagination in Contemporary Art* (New York: Midmarch Arts Press).
33 Elkins, *On the Strange Place*, 47.
34 Promey, *The "Return" of Religion*, 587–588.

acknowledges the enduring presence of religion, and spirituality in a broader sense, in contemporary artistic practices and thought, that is in fact not the main point of the book. By means of the term 'strange,' he characterizes the contested position of religion in the interpretative grids around artistic practices.

In response to this general observation of the paradoxical position of religion in art writing and theory, the 2007 *Art Seminar* roundtable project organized by Elkins and David Morgan was an admirable attempt to tackle this 'strangeness.' With a group of invited scholars they explored what it would take to bridge the gap between the modernist, secular-driven academic discourse on art and those propagating more attention for the presence of religion in art. Resulting in a book publication titled *Re-Enchantment*, it features background essays, transcriptions of the roundtable discussions, written responses, and two afterthoughts.[35] The final contribution by Erika Doss is suitably titled 'The Next Step?,' which departs from the observation how most of the participants in The Art Seminar "agreed that theorizing religion in the consideration of modern and contemporary art was 'problematic'."[36]

The acknowledgement of a complex, yet much-needed analytical position for religion in the study of art can be seen as one of the root-causes underlying the emergence of the notion of the postsecular. Doss identifies several aspects that are required in 're-imagining religion's contemporary visual presence,' including broadened and more-inclusive understanding of both art and religion, its connections to national stakes and nationalist interests in reinforcing senses of shared purpose and belonging, the recognition of where art and religion 'happen, and how they are felt.' Both art and religion are constructed through 'lived encounter and experience,'[37] demanding critical academic discourse that facilitates this. Observing recent tendencies in scholarship refusing to act on anxieties about emotive or affective characteristics,[38] no longer privileging "seemingly more objective and conceptual approaches,"[39] Doss concludes,

35 James Elkins, David Morgan (eds.). 2009. *Re-Enchantment* (New York, London: Routledge).
36 Erika Doss. 2009. "The Next Step?" in James Elkins and David Morgan (eds.). *Re-Enchantment*, edited by (New York, London: Routledge) 297.
37 Doss, *The Next Step?* 299–300.
38 Laurent Berlant. 2004. "Critical Inquiry, Affirmative Culture," *Critical Inquiry* 30.2004: 445–51; Brian Massumi. 2002. *Parables for the Virtual: Movement, Affect, Sensations* (Durham: Duke University Press).
39 Doss, *The Next Step?*, 300

(...) put simply, both subjects are visual, material, intellectual, and emotional bodies whose social, cultural, and political significance cannot be adequately considered without a simultaneous appreciation of their affective nuances. Critical discourse that pursues these approaches may well generate the sort of creative and compelling analysis that the 'problematic' subjects of art and religion sorely deserve.[40]

As Elkins mentioned during the 2017 Biola University symposium, several scholarly discourses offer potential routes to break open the current interpretative grids, allowing for at least a presence of 'crypto-religious discourse:' object-oriented ontology, phenomenology, and affect-theory.[41] These three, philosophically rooted analytical discourses share the aim of integrating the transcendent, experiential, ineffable or unsayable as a resource of knowledge. In addition to the materiality of an artwork, its immaterial dimensions are of equal importance if we are to understand any of its spiritual qualities.

Such discourses allow for an understanding of religion in terms of, as Hans Belting characterized it, 'presence' rather than only in terms of 'likeness,' via symbols or iconography.[42] Belting argues how the pre-modern conception of divine presence embodied in religious and devotional objects got lost in the treatment of artistic objects by individuals as much as by museum professionals and art historians when the modern concept of 'art' was introduced. Instead of approaching it as embodied presence, modern conceptions located religion in representational images, iconography, in likenesses to the referential, visible world featured in the objects. This defined and contained perception of religion has impacted art historical scholarship until this day.

The argument is furthered by Promey, who in response to Elkins, reinforced how materiality played a crucial role in secularization theory's locating of religion in pre-modern and modern times. Pre-modern religion is materialized in objects, which are characterized as idols, invested with superstitions, turning them into totemic and fetish objects. In turn, modern religion is individual and interiorized, rather than being a matter of objects, it becomes a matter of the heart and mind.[43] In this difference, modern materiality has an illustrative

40 Idem.
41 James Elkins. 2017. "Art History in a Postsecular Age," Symposium *Art in a Postsecular Age*, Center for Christianity, Culture, and the Arts, Biola University, La Mirada, CA., 4 March. http://ccca.biola.edu/resources/2017/mar/6/art-postsecular-age/.
42 Hans Belting. 1994 (1990). *Likeness and Presence: A History of the Image before the Era of Art* (Chicago: University of Chicago Press).
43 Sally Promey. 2017. "Art History in a Postsecular Age," Symposium *Art in a Postsecular Age*, Center for Christianity, Culture, and the Arts, Biola University, La Mirada, CA., 4 March. http://ccca.biola.edu/resources/2017/mar/6/art-postsecular-age/.

or representative role, while pre-modern materiality functions in an embodied manner. Using categories like 'primitive,' 'naïve,' or 'outsider' art, continues "to other the religious. Religion can exist in all the categories, except for fine arts."[44] Underlining Belting's distinction between likeness and presence, Promey sees the acknowledgement of this differentiation—and its theoretical and methodological implications—taken up across multiple academic disciplines, but not art history.

With the persistence of the category of 'fine art,' scholarship and museum practices reinforce the perception of visual art as an inherent independent entity, independent of, first, religion and, second, politics. Gordon Graham identified this perceived independence as an aspect of the aesthetic approach to art, rooted in eighteenth-century philosophical debates. This aestheticism had several important implications for the general perception of art and its societal function. As Graham formulates it, "though art and religion have long been connected, the history of their relationship is best understood as a progressive development in which art gradually secured its autonomy from the service of religion and became a source of inspiration its own right."[45] In turn,

> this independent source of inspiration derives from a distinctive kind of experience—aesthetic experience. Aesthetic experience is not to be confused with the sort of empirical data on which the acquisition of scientific knowledge rests. Nor is it to be identified with the deliverances of moral sense or mystical encounter. Aesthetic experience is an apprehension of beauty, and something we simply take delight in.[46]

The aesthetic conception of art privileged beauty and formal features over other dimensions of art, such as the religious or spiritual. Graham revokes Belting's differentiation, by distinguishing artistic practices before and after the invention of the concept of 'art.' Everything before "the emergence of art proper can be regarded as *incipient* art—art, certainly, but in a somewhat disguised form and easily interpreted as the promotion or affirmation of religion."[47] The purpose or function of this art transforms in secularized societies, in which objects such as altarpieces or icons are largely appreciated for its aesthetic qualities, but hardly at all for its religious contents. Religious art that is made after the emergence of 'art proper' is generally regarded as a type of propaganda, like

44 Idem.
45 Gordon Graham. 2017. *Philosophy, Art and Religion: Understanding Faith and Creativity* (Cambridge, New York: Cambridge University Press). E-book: Chapter 6.
46 Idem.
47 Idem, emphasis in original.

commercial or political art. Perceived as serving other purposes than artistic integrity, this art is regarded as a sub-category.[48]

The eighteenth-century emergence of art proper, and its underlying suppositions, was institutionalized in public sites like museums, theaters, festivals, libraries, art academies, and concert halls. These sites "advanced and sustained the conception that gave rise to them."[49] Or, as Carol Duncan put it, "the appearance of art galleries and museums gave the aesthetic cult its own ritual precinct."[50] In its institutionalized form, aestheticism in turn, ironically, served a larger purpose. Tony Bennett characterized the creation of public sites, like the art museum, as the emergence of a 'cultural technology.'[51] Through combining aesthetic delight with education, cultural technologies served the purpose of organizing the populations of newly formed nation states. Their governance, and the framework of norms and values it was based on, were no longer relying on religious institutional ties as heavily as they had before the revolutionary eighteenth century. Since their foundation in the late eighteenth and early nineteenth-centuries, public museums have been regarded as temples of modernity, signifying secular values.[52] As products of Enlightenment culture, they are generally regarded as institutions exerting a secular truth, "truth that is rational and verifiable—that has the status of 'objective' knowledge. It is this truest of truths that helps bind a community into a civic body by providing it a universal base of knowledge and validating its highest values and most cherished memories."[53]

Visual art, through historical, mythological, and religious subject matter, played an essential communicative role in the shaping of new communal narratives. As Duncan observed, "Art museums belong decisively to this realm of secular knowledge, not only because of the scientific and humanistic disciplines practiced in them—conservation, art history, archeology—but also because of their status as preservers of the community's official cultural memory."[54] In addition to the intended formative role of museums, their methods of display, and the formation of accompanying narratives, this newly acquired public function of art not only reinforced a shared and celebratory role. It also allowed for a larger critical potential. The shaping of new narratives in-

48 Idem.
49 Idem.
50 Carol Duncan. 1995. *Civilizing Rituals: Inside Public Art Museums* (London: Routledge) 14.
51 Tony Bennett. 1995. *The Birth of the Museum: History, Theory, Politics* (New York: Routledge).
52 Duncan, *Civilizing Rituals*, 7.
53 Idem, 8.
54 Idem.

vited counter-narratives, in response to the newly formed political institutions and structures, and in response to the traditional religious institutions aiming to find new modes of legitimacy and power.

The earliest public art museums in Western Europe and the United States consciously copied and appropriated the architecture from classical Greek temples. As such, the comparison to the function of temples was easily made, while the use of columns, tympanums, and friezes were intended as a visual expression of public authority. It was a mode of building that Gretchen Buggeln characterized as 'the associative mode:' "museum architecture or exhibition design [that] can evoke the sacred through direct material references to the worship environments of a religious tradition."[55] The historical status and authority was translated into a new, secular project. The architecture and the evocation of new, shared, and collective narratives turned museums into sites that "publicly represent beliefs about the order of the world, its past and present, and the individual's place within it."[56] Since the eighteenth century the public order of the world had become secularized, which was to be reinforced by new institutions like the art museum.

The equation of art museums with traditional religious institutions is most effective when looking from a ritual studies perspective. This perspective is developed by Duncan, who demonstrated how particularly western museums of modern art present ritual scenarios reinforcing norms and values informed by secular, liberal, and capitalist ideologies. Modern art museums across the western world tend to have similar collections, based on the same perception of a canon of modern art, and display them in similar fashion. Starting with French Realism and Impressionism, via the various -isms like pointillism, cubism, surrealism, and expressionism, ending with modern abstraction and Pop Art. The presentations of these consecutive developments are often implicitly based on the idea that the more 'modern' art became, the higher moral and progressive standards were obtained. It is an exclusionary narrative, in which religion hardly has an integrated presence. It reflects Graham's observation about the status of religious art production after the emergence of art proper. Other art forms, outside the canon, are acknowledged, but not valued on a similar level. In a museum context, such displays are not merely a case of an art historical story. Given the societal position of the museum as a public institution, there are ideological stakes at play. As Duncan describes it,

55 Gretchen Buggeln. 2017. "Museum Architecture and the Sacred: Modes of Engagement" in Gretchen Buggeln et al. (eds.). *Religion in Museums. Global and Multidisciplinary Perspectives* (London: Bloomsbury) 12.
56 Duncan, *Civilizing Rituals*, 8.

> To control a museum means precisely to control the representation of a community and its highest values and truths. It is also the power to define the elative standing of individuals within that community. Those who are best prepared to perform its ritual—those who are most able to respond to its various cues—are also those whose identities (social, sexual, racial, etc.) the museum ritual most fully confirms.[57]

The ritual scenario Duncan uncovers in the modern art museum exerts ideas about progress, each next art movement following, emulating, and discarding of the previous. "[T]he modern art history that counts—moves always forward."[58] Throughout the twentieth century, this moving forward has concerned itself with finding greater degrees of abstraction and discarding of skills like linear perspective that allowed for greater illusionism and improved representation. Traditional skills, central to the development of western art for a long time, were replaced with new techniques such as the use of chance, automatic drawing, or intentionally unlearned painting. The idea of modern artistic progress is tied up with "the distance it travelled in emancipating itself from the imperative to represent convincingly or coherently a natural, presumably objective world."[59]

Duncan connects this to a perceived sense of morality, "the more artists free themselves from representing recognizable objects in space, the more exemplary they become as moral beings and the more pious and *spiritually* meaningful their artistic efforts."[60] It is a conception of a spirituality that has nothing to do with religious doctrine or esoteric interests, and everything to do with artistic integrity.

While it is undeniably true that most modern art museums in Western Europe and the United States still look very similar, in the make-up of their collections and the modes of display—slowly but steadily changes seem to intersperse. This mostly has to do with the questioning of the canon. Increasingly, modern art museums direct their attention to long-ignored and outsider artists, which were (and are) not part of any art historical canon. The challenging of the canon relates strongly to identity: twentieth-century women artists, as well as artists from cultural and ethnic minorities, those working outside the mainstream world of museums and galleries, and non-western artists are increasingly gaining attention of museum curators. While the attention for

57 Idem.
58 Idem, 108.
59 Idem.
60 Idem, emphasis in original.

these types of artists is incredibly important, their framing remains problematic, as this often occurs in relation to a traditional conception of the canon. Not being part of the art historical canon has become a legitimate reason to become topic of an exhibition. While attention for and representation of previously ignored artists constitutes a positive development, the frame in which they are presented often continues to simultaneously reinforce a traditional conception of the canon.

Even more remarkable is the continued problematic nature of religion in these latest developments. While the notion of the spiritual is becoming more acceptable for museum curators as a term to work with (as will be explored in Chapter 4), religion still seems a notion with challenging implications. It does not fit the long-professed narrative on moral progress, which in turn is strongly rooted in secular convictions. The societal positioning of museums as secular sites reinforces this complexity as well. As John Reeve observed, "There are (...) few museums that prioritize presenting and interpreting religions, yet religious beliefs are now, more than ever, a major area of public discussion, controversy and media attention, prejudice and misunderstanding."[61] In addition to the museum's secular self-identification, this complex and heated public perception makes the presence of religion in museums an even more delicate subject. Yet, one that should not be avoided. "Most museums and galleries have material that relates to religions and other beliefs, but usually without any consistent approach to it. As a profession, we are still cautious about entering this particular secret garden."[62]

Being perceived as 'secular guardians of religion artifacts,'[63] museums have to come to terms with the various approaches to religion they could, and perhaps should, take. Reeve posits several important tasks for museums to consider: collaborations with representatives of faith communities, to reinforce that religious knowledge is produced not by curators but out in the field; the presented interpretations around collections and exhibitions should be multi-voice, rather than single-handedly authoritative; and museums should be less afraid to take up an active role in contemporary public debates around religion.[64]

61 John Reeve. 2012. "A Question of Faith: The Museum as Spiritual or Secular Space" in Richard Sandell and Eithne Nightingale (eds.). *Museums, Equality, and Social Justice* (New York: Routledge). E-book: Chapter 9.
62 Idem.
63 Karen Chin. 2010. "Seeing Religion with New Eyes at the Asian Civilizations Museum," *Material Religion* 6.2: 215.
64 Reeve, *A Question of Faith*. Chapter 9.

Museums ideally function as critical discursive sites, in which artworks—with their own discursive potential—on the one hand function as strong voices of their own, while on the other hand as invitations for wider engagement from curators, visitors, and audiences at large. When religious themes or iconography are used to question or critique religion, its practices, or institutions, the museum has the power to offer a safe space where public debate can take place. As long as these discussions take place in a multi-vocal manner. Simultaneously, visitors attend museum exhibitions for their own, individual, motivations. These motivations may be of aesthetic, educational, or ritual nature. In all of these, a transcendent relationship of some sort is established, through the artwork, with the artist, the time and context of production, the zeitgeist, and other viewers who have engaged with the artwork overtime. This inherent ineffable character of engaging with art, and people's longing for that, is often theorized as enchantment.

2.2 *Enchantment*

While, over the last two decades, scholarship has increasingly focused on religious objects in museums, the implications of religion in art proper, or the relationship between art and religion, remain subject for further study. Other fields, besides art history, in which art and religion constitute a popular research topic are most notably theology, anthropology, philosophy, and religious studies—the latter with its continuously growing and popularizing sub-discipline of material religion. A—if not, the—key term in non-art historical approaches to art and religion is that of enchantment, and its counterpart of disenchantment. Coinciding with the return of religion-narrative, the notion of re-enchantment is used to indicate a return of individual and collective needs for the mysterious, magic, spiritual, or, simply put, enchantment. The scholarly approaches to enchantment, disenchantment, and re-enchantment are rooted in secularization narratives and its societal implications.

The notion of enchantment leads inevitably to the work of Max Weber, who borrowed the notion of *Die Entzauberung der Welt* [the disenchantment of the world] from a 1788 poem by Friedrich Schiller.[65] Weber posited this term to describe how modern capitalist society's driving processes of rationalization and scientific measurement pushed pre-modern virtues based on belief and experience to the margins of society and in the experience of everyday life. For Weber, the term disenchantment described the implicit operations of modernity, having "two distinct aspects (…). On the one hand, there is

65 Richard Jenkins. 2000. "Disenchantment, Enchantment and Re-Enchantment: Max Weber at the Millennium," *Max Weber Studies* 1: 11.

secularization and the decline of magic; on the other hand, there is the increasing scale, scope, and power of the formal means-ends rationalities of science, bureaucracy, the law, and policy-making."[66]

Recently several excellent explorations of the legitimacy and the contemporary implications of Weber's conceptions of disenchantment have been published, especially in relationship to philosophy, natural sciences, and magic.[67] In the context of this work on the postsecular, of particular interest is the impact of disenchantment on the perceived role of the arts in modern societies, and how this role tends to be generally characterized in terms of enchantment. Elkins and Morgan's roundtable calling for greater religious understanding in art history is titled *Re-Enchantment*, Beckford's qualification of the field of arts as a postsecular domain is called *The reenchantment of culture*. As such the notion of enchantment, and its linked processes of dis- and re-enchantment, seem of determining nature in the postsecular understanding of how the arts operate in an increasingly modern world.

Secularization and disenchantment are often characterized as simultaneous processes, but they are not of synonymous character. Marcel Gauchet presents the argument that as societies become more advanced and developed, religion becomes less advanced. In his view, the emergence and institutionalization of Christianity pushed essential forms of religion, as experienced in pre-Christian societies, to the margins. Early societies demonstrated a complete sense of submission and awe in recognition of a pre-determined plan. In more modern societies, the power of agency has become invested with the individuals that make up one society. As such, according to Gauchet, modernization paved the way for modern secular societies, by means of the rise of the state, the emergence of monotheism, and the inner movement of Christianity. These developments constitute a paradox of modernity, "when dealing with religion, what appears to be an advance is actually a retreat."[68] Gauchet characterizes this paradox as disenchantment, calling Christianity a 'religion for departing from religion.'[69]

66 Jenkins, *Disenchantment, Enchantment and Re-Enchantment*, 12.
67 Respectively, Bradley O'Nishi. 2018. *The Sacrality of the Secular: Postmodern Philosophy of Religion* (New York: Columbia University Press); Egil Asprem. 2014. *The Problem of Disenchantment: Scientific Naturalism and Esoteric Discourse 1900–1939* (Leiden: Brill); Jason A. Josephson-Storm. 2017. *The Myth of Disenchantment: Magic, Modernity, and the Birth of the Human Sciences* (Chicago: University of Chicago Press).
68 Marcel Gauchet. 1999. *The Disenchantment of the World* (Princeton, NJ: Princeton University Press) 10.
69 Idem, 4.

While this interpretation of disenchantment is subject to debate, the connection Gauchet makes between what he calls 'essential' forms of religion, a complete recognition of power situated outside one's own individual agency is of great relevance in relation to the notion of enchantment and the experiential dimensions of art. In the analysis of contemporary societies, the field of the arts is regarded as a key site where enchantment takes place. Even more so, the arts are seen as a site where enchantment is valued and cherished. In the arts, the extent to which an artwork has the power to enchant has become a measure of evaluation.

Many authors attempt to understand the prevailing relationship between enchantment and art, and how it fulfills a certain longing for people. Some are more hesitant than others. By evoking the comparison between Apollo and Dionysus—the sons of Zeus respectively representing rational thinking, logic, and purity, and irrationality, emotions, and chaos—Graham's observations on the religious potential of art are not very hopeful. "Painting alone will never let us see the sacred; fiction as such provides no cosmic pattern of life; music alone has developed in a direction that eliminates the Dionysian altogether."[70] Although humans have the ability to "stock the world with beauty, interest, the clever, and the captivating,"[71] it will never transcend the realm of human agency. This leads Graham to observe that, "while we can build ourselves a different type of sacred space, we lack the right kind of festival with which to fill it. In short, the abandonment of religion, it seems, must mean the permanent disenchantment of the world, and any ambition on the part of art to remedy this is doomed to failure."[72]

Yet, in the very last sentences of his 2007 book *The Re-Enchantment of the World: Art vs. Religion*, Graham encourages his readers not to despair. Most of the philosophical theorization about enchantment is based upon a perception of an evolutionary and progressive development of modernity, in which Europe has a critically central role. This implies that Europe sets the example for the future of the rest of the world. Yet, Graham observes, "the phenomenon of globalization, and with it an awareness of the power and presence of religion in the modern world, ought to alert us to the possibility that the idea of secularization, and the related debate about the consequences of secularism, may be a relatively local, and even minor, affair, confined to two centuries of

70 Gordon Graham. 2007. *The Re-Enchantment of the World: Art versus Religion* (Oxford, New York: Oxford University Press) 186.
71 Idem.
72 Idem.

European history."[73] Therefore, when we ask of art to be a replacement or alternative to the enchantment previously facilitated by religion, we simply ask too much.

This, in turn, is an insight that will come to us overtime, so Graham believes. "The human spirit may for a time forget, but instinctively knows,"[74] when we are done searching and realize religion provided it all along. As Graham ends on this profoundly theological note, I think his analysis of the place of art in the human struggle for enchantment is exemplary for the recent emergence of the postsecular. Religion is increasingly found outside of fields that are self-evidently religious,[75] in which it co-exists and merges with the secular into new intertwining forms of enchantment. So, within such intertwining forms, traditional or institutional elements of religion still have a place.

By coining the notion of 'enchanting secularity,' Jeffrey Kosky tried to identify the workings of such intertwined forms through art.[76] In doing so, he expresses a certain unease with the postsecular, which he simultaneously is prepared to eventually let go. The unease begins with the ambiguous meaning of the 'post' in postsecular. As Kosky wants to acknowledge the secular state of contemporary society, his departure points are enchanting moments and contexts in these secular surroundings. For his 2012 book *Arts of Wonder*, Kosky staged personal encounters with works by artists that are known for their interest in existential themes: Walter de Maria, Diller and Scofido, James Turrell, and Andy Goldsworthy.

In the encounters with the selected works of art, Kosky sees traditional theological resources as vital in making sense of his experiences. As he put it during his contribution to the 2017 Biola University symposium, "my approach to enchanting secularity may imply that recourse to traditional religion or religious traditions is not necessary for refuge from the malaise of disenchantment in a disenchanted world."[77] Which he identifies as another reason of why he feels uncomfortable using the term postsecular. "It risks denying those resources. But my encounters could not have taken the shape they did, had my interpretative

73 Idem.
74 Idem.
75 Courtney Bender. 2012. "Things in their Entanglements" in Philip S. Gorski et al. (eds.). *The Post-Secular in Question: Religion in Contemporary Society* (New York, London: New York University Press). E-book: Chapter 3.
76 Jeffrey L. Kosky. 2012. *Arts of Wonder, Enchanting Secularity* (Chicago, London: University of Chicago Press).
77 Jeffrey Kosky. "What is Post-Secularity?" Symposium *Art in a Postsecular Age*, Center for Christianity, Culture, and the Arts, Biola University, La Mirada, CA., 4 March. http://ccca.biola.edu/resources/2017/mar/6/art-postsecular-age/.

take on them not been informed by reading religious texts and authors."[78] However, this engagement with theological resources makes him oppose the ideology of secularism and how it treats religion. Which then leads him to conclude, "Enchanting secularity might very well be postsecular then, if postsecular means moving beyond the secularism that refuses anything but an adversarial engagement with religion."[79]

Kosky approaches enchanted secularity as a mode of living in the world, one that is attentive towards affect and affectiveness. He sees religion not as a resource of answers to existential questions, rather as support to inhabit such questions. A similar affective approach to enchantment, but with alternative implications, is presented by David Morgan in his 2018 book *Images at Work*. Morgan, known for his work on religious visual culture and explorations of engagement with religious art through what he called a 'sacred gaze,'[80] presents enchantment as a process that has always been around, as long as humans have interacted with material objects and visual imagery. "[T]o be enchanted means to lose control at the hands of a device or feeling or experience that places one in the service of another. (...) To be charmed, bewitched, or enchanted often means diversion from routine or fascination with something novel."[81]

Morgan sees this experience of being enchanted to consist of two routes in which agency is transferred. "Enchantment is, on the one hand, a way that people manage the worlds in which they live and, on the other hand, a power things exert over us. In other words, enchantment is something we do to the world and something the world does to us."[82] In both routes the experienced transferal of agency positions a form of power beyond the realm of individual agency, requiring a type of submission and belief reminiscent of Gauchet's conception of essential religious attitudes. For Morgan, enchantment is "a symbolic act or instrumental gesture that triggers a metamorphosis."[83] This is never a one-on-one relationship between viewer and image, but can only be established in the context of a larger network of 'enabling factors.'[84] Such factors are for instance the shared narratives upheld by a community, in which

78 Idem.
79 Idem.
80 David Morgan. 1997. *Visual Piety: A History and Theory of Popular Religious Images* (Berkeley, Los Angeles, London: University of California Press); David Morgan. 2005. *The Sacred Gaze: Religious Visual Culture in Theory and Practice* (Berkeley, Los Angeles, London: University of California Press).
81 David Morgan. 2018. *Images at work: The Material Culture of Enchantment* (Oxford, New York: Oxford University Press) 2.
82 Idem, 9.
83 Idem, 17.
84 Idem, 19.

particular meanings are attributed to images, the physical environments in which images are encountered, or the personal particularities of the moment in life when an image is encountered. A range of internal and external factors enable either of the two-fold routes of enchantment.

Morgan furthermore distinguishes between enchantment of 'make-believe' and enchantment of 'belief,' the first results from fiction, the second from a perception of truth. Both are grounded in a suspension of disbelief, but of different nature. "The enchantment of belief is a way of feeling and acting in which people take something to be certain and enduring. The enchantment of make-believe is what people do when they act *as if* something were true without being certain or enduring. Make-believe delights in temporary conditions; belief does not."[85] Other ways of expressing this distinction are the difference between 'artifice' and 'artifact,' or 'fake' and 'fact.'[86] It determines the manner in which an image or art object is experienced: is an artwork seen as make-believe or an imitation, or as constituting an actual fact of life, to which one can relate a sense of agency?

Morgan's approach, rooted in actor-network and reception theories, does not see the artwork as a static object, which functions passively when humans engage with it. And it does not see the context, whether it is one's dining room, a gallery or a public art museum, as a static and neutral given. Rather, such a dynamic approach formulated by means of the notion of enchantment takes part in the 'objectual' turn in the study of art. This turn regards objects as "active interlocutors in a three-way conversation along with museums [or other locations, LW] and visitor to museums, and that like the objects and the viewers, museums themselves stand to be transformed by this interaction."[87] Such an approach to artworks and their socio-cultural functioning fits within the growing domain of theories on response and reception, as pioneered by David Freedberg and James Elkins.[88]

Since the last decade of the twentieth-century, in the arts that are produced in secular societies religion is no longer only found in traditional representations, iconography, and symbolism. Through the notion of enchantment, it has been even more so located in the engagement with artworks by believers and

85 Idem, 27–28. Emphasis in original.
86 Idem, 28.
87 James Clifton. 2014. "Conversations in Museums" in: Sally Promey (ed.). *Sensational Religion: Sensory Cultures in Material Practice* (New Haven, London: Yale University Press) 205–206.
88 David Freedberg. 1989. *The Power of Images: Studies in the History and Theory of Response* (Chicago: University of Chicago Press); James Elkins. 2001. *Pictures and Tears: A History of People Who have Cried in Front of Paintings* (New York: Routledge).

non-believers alike. By investing a type of experiential power in the objects and the contexts in which these are displayed, the default position of artistic practices and arts institutions as secular sites is challenged. It draws scholarly attention to new forms of religious engagement with the arts, artistic engagement with religion, and the impact of the perceived secular societal contexts in which these practices take place. The ever-growing variety of religious and spiritual practices, and the unlimited potential for artistic practices to respond to—and embody—these, bring us to the next process of importance in the construction of a postsecular understanding of the arts: diversification.

3 Diversification

On 16 October 2018, Taco Dibbits, the director of the Rijksmuseum in Amsterdam, announced during a press conference that the museum's most famous painting would become subject to a large-scale restoration project. Over the summer of 2019, Rembrandt's *Nightwatch* (1642) will be restored in public, so visitors can follow the process and not be deprived of a glimpse of the painting during their museum visit. Dibbits made this announcement at a well-attended press conference, where the Minister of Culture, Ingrid van Engelshoven, and the Mayor of Amsterdam, Femke Halsema, accompanied him. While the Minister accounted for the national importance of preserving the *Nightwatch* for future generations, the Mayor emphasized the painting's symbolic function for the city of Amsterdam. In her statement she recounted how this group portrait is "a symbol of our city, how people of various denominations, catholic, remonstrant, and protestant, are united in their service to Amsterdam."[89] Despite the fact that this painting features only white men from the seventeenth-century societal elite, Halsema found a way to frame it as exemplary of the (current) diverse nature of Amsterdam by pointing at their religious diversity. As such, she instrumentalized the *Nightwatch* in a shared narrative for the citizens of Amsterdam and, just like that, the painting became part of twenty-first-century identity politics.

If one term describes the contemporary constellation of Western European societies, 'diversity' may just be it. Societies are increasingly less characterized

[89] Paola van de Velde. 2018. "Nachtwacht geeft straks alle Geheimen Prijs [Nightwatch to Reveal all Secrets]," *Telegraaf*, 16 October. https://www.telegraaf.nl/nieuws/2685678/nachtwacht-geeft-straks-alle-geheimen-prijs. The original reads, "Dit schutterstuk is een symbool van onze stad, hoe mensen van diverse gezindten, katholiek, remonstrants en protestant samen zich inzetten voor Amsterdam."

as majority-minority constellations, but more and more as a constellation of minorities. With the term 'superdiversity,' Stephen Vertovec conceptualized the continuous diversification of diversity.[90] Especially characteristic of densely populated urban areas like London, New York or indeed Amsterdam, such diversity is found in terms of ethnicity, nationality, and religiosity alike. If the public sphere is identified in such terms, its public institutions should ideally be representative of this diversity. As a result, museums are increasingly aware of the need to install diversity policies, internally and externally. Their staff needs to be representative, while their visitors and the manners in which collections are approached and displayed need to be so as well. Participation programs are increasingly targeting minorities that do not necessarily find their way to the museum themselves.

Targeting a more varied audience also means a need for new strategies of finding relevance of religious heritage. The first part of this chapter takes the notion of 'translation' as a departure point to describe several such strategies. Translation is overall regarded as fundamental for the appreciation, and enduring presence, of religion in the contemporary public sphere. Jürgen Habermas argues for the essential function of translation of religious vocabulary and imagery for secular audiences and institutions. As I argue in this chapter, translation also needs to take place the other way around and can only exist in a relationship of mutuality. Such dynamics of mutuality take place in a variety of translation strategies between the religious and the secular. Rather than reinforcing the religion-secular binary, as some scholars fear, such strategies seem to lead to new artistic and institutional formations. Three particular translation strategies are identified: reformulation, the finding of new vocabularies that build further on existing religious heritage; ludification, the creation of playful combinations of religious imagery and vocabulary; and re-presentation, the reframing of existing, historically, and traditionally rooted religious art and heritage.

Translation strategies can only be employed fruitfully in a context of mutuality, or at least when an effort at mutual understanding is attempted. In the contemporary state of modernity, which Zygmunt Bauman characterized as liquid, ongoing negotiations about meaning and its potential transformations is required. Diversity also implies a co-existence of pluriform voices and outlooks, between which interaction—let alone understanding—is not guaranteed. Lack of knowledge is often a cause for indifference and misunderstanding. This especially occurs when religious imagery is artistically processed in

90 Steven Vertovec. 2006. "Towards post-multiculturalism? Changing communities, conditions and contexts of diversity," *International Social Science Journal* 64.199: 83–95.

provocative or challenging manners. The freedoms of religion and artistic expression do not seldom clash. As such, offense has become a recurrent feature in religiously diverse societies. Yet, simultaneously, I would argue, art also has the potential to foster debate between the realms of these two freedoms, and as such contribute to efforts of mutuality.

In response to the diversifying constellation of the communities around them, art institutions increasingly create room for new and alternative imaginaries. These are often found in socio-cultural margins, artistic practices that are not included in, or question the, art historical canons, and new generations of artists who take inspiration from a variety of sources and create new (religious) configurations.

3.1 *Translation and Its Strategies*

Parallel to the secularization of the public sphere and the changing sociocultural position of religious institutions in Europe, runs a transforming religious literacy. Generally formulated: if younger generations no longer understand the symbolism the older generations grew up with, how can the art representing this be kept interesting and relevant? This is just one question, which reflects larger societal implications when it comes to the relevance of religious institutions in the public sphere. A key figure on this topic is Habermas, who in numerous publications, presentations, and public debates has argued for both the 'preservation' and 'translation' of religious heritage in the secular public sphere.[91] Where he maintains that in certain public institutions, like courts, parliaments, and ministries, there is no place for religion, he simultaneously argues that religious language embodies ethics, morals, or values that can be of relevance for secular and non-religious public actors. He does not argue for abandonment of secular rationality, nor for the reintroduction of state religions. Instead, he calls upon a mutual conversation and understanding. As such, secularists should not per definition discard religious language and religiously rooted arguments. For Habermas, the postsecular is therefore a much-needed correction on the outlook long maintained by secularists. It

91 Henk de Roest. 2015. "Lessen van Religies: Jürgen Habermas en de onmisbaarheid van Religieuze Gemeenschappen [Religious Lessons: Jürgen Habermas and the Inevitability of Religious Communities]" in Govert Buijs and Marcel ten Hooven. *Nuchtere Betogen over Religie: Waarheid en Verdichting over de Publieke Rol van Godsdiensten* [Sober Pleas about Religion: Truth and Fiction about the Public Role of Religions] (Budel: Damon, 2015) 218.

embodies a call for respect and, at the very least, an attempt of mutuality between religious and secular actors.[92]

This also includes a task for religion. And that task is translation. Focusing on religious language and semantics, Habermas argues that religious actors, in their contributions to public debates, need to translate theological language into secular semantics. For example, discussions about grace, forgiveness, or equality in the face of God need translation into notions of human rights and equal freedoms. Critics of Habermas have argued that in this translation process, the essence of the theological discourse gets lost.[93] Yet, for Habermas such translation is a prerequisite for religion's continued presence, and relevance, in the public domain.

At its very core, decreasing religious literacy demands a change of approach. With continued declining church attendance and religion being transformed in sites outside of the institutional domains, the demand for transformed (if not translated) modes of expression seems an inevitable consequence. When it comes to the arts, new layers of relevance need to be found through new modes of visual interpretations, based on traditional iconography and semantics. While Habermas solely focuses on language, since the nineteenth century the field of the arts has demonstrated to be very resourceful when it comes to translations between religion and the secular.

In post-revolutionary Europe, emerging nation states needed to create new shared narratives for its citizens. No longer connected through one state-endorsed church, the people previously under God now needed a new narrative to unite them—and accept the new political structures as legitimate. The power was no longer divinely endorsed, but profanely elected. The sacred became in need of redistribution. Robert Rosenblum used the term 'secular translations' to describe how artists of the Romantic era drew from Christian imagery to frame and represent "modern semi-divinities—new martyrs, new heroes, new heads of state."[94] In Western Europe, artists like Jacques-Louis David, Jean Auguste Dominique Ingres, and Francisco Goya created new iconic images. In the Anglo-American world this task was taken up by painters like Benjamin West and John Singleton Copley. Official portraits presented

92 Herman Paul. 2017. *Secularisatie: Een Kleine Geschiedenis van een Groot Verhaal* [Secularization: A Small History of a Large Narrative] (Amsterdam: Amsterdam University Press) 112.
93 Idem, 113.
94 Robert Rosenblum. 1975. *Modern Painting and the Northern Romantic Tradition: Friedrich to Rothko* (New York: Harper and Row) 17.

new leaders as saints, depictions of leaders lost in battle reflected the iconography of the pieta. "In both Catholic and Protestant countries, these transvaluations of Christian experience were inevitably based on the corporeal motifs inherited from Christian iconography: palpable visions of earthly tragedy or heavenly grandeurs as conveyed through noble figural compositions."[95]

This use of Christian iconography and its connotations are the precursors to what Robert Bellah has described as 'civil religion.'[96] The dynamics of political and stately institutions being endowed with divine characteristics, providing them with a character of being timeless and ever just. It demands further attention from scholars, as Erika Doss argues. "Recognizing the real-time, real-life connections of contemporary art and religion requires further critical attention to how modern nations, and notions of nationalism, are deeply invested in both in order to sacralize their own operations and ensure public loyalty."[97] Institutionalized forms of religion are appropriated for these public purposes. "Public art and architecture, like public rituals and ceremonies, are all forms of civil religion that help to mobilize particular forms of national consciousness, civic and social identification, and shared purpose."[98]

In addition to such state-regulated art forms, the religion-secular translations also found their way into modern art movements depicting less official subject matter. Just think of *L'Angélus* (1857–59) by French painter Jean-François Millet, portraying two peasants praying in the midst of the fields. In the most grand of matters, Millet portrays these figures as timeless icons of devotion. Throughout the twentieth century such translations are used for purposes of societal or cultural commentary, for example in the reinterpretations of stained-glass art by British artists Gilbert and George, the contemporary saint portraits by American painter Kehinde Wiley, or the restaging of Christian iconography in urban, capitalist, and over the top utopian settings by American photographer David LaChapelle. All these artists tap into the iconic characteristics of traditional symbolism and use it to create a societal statement through a sense of authority and timelessness.

While it indicates a widespread intertwinement of religious and secular elements in artistic practices, the term translation has a somewhat problematic character. First, it seems to reinforce the binary categories of religion and

95 Idem.
96 Robert N. Bellah. 1967. "Civil Religion in America," *Daedalus, Journal of the American Academy of Arts and Sciences* 96.1: 1–21. Available via: http://www.robertbellah.com/articles_5.htm.
97 Doss, *The Next Step?*, 300.
98 Idem.

the secular and reduces it to an essentialist view of both. Anything that goes beyond these categories is no longer in need of translation, only the very essentialist perceptions of what, predominantly institutionalized, religion is and what the secular is, or at least how secularists perceive religion.

Second, in line with this, the notion of translation seems to imply as if there is no direct interaction between these two domains in the public sphere. Yet, the reason why the notion of the postsecular has emerged in the first place, is the widespread observation that numerous new formations of religion and the secular exist and continue to emerge. The term translation needs to include awareness of the emergence of such entangled formations as demonstrated by the field of the arts *per excellence*. New forms do emerge and are sustained, in which both religious and secular roots merge into new constellations.

Third, I would argue, the issue with translation, for its Habermassian focus on language, is that it indicates a rather one-dimensional process. Crudely put: one religious sentence is translated into a secular sentence, and transmitted as such from one party to the other. Meanwhile, as reflected by artistic practices, the translation process is as fluid as its transmitting to a variety of audiences can be. The co-existence and occasional merging of religion and the secular, in my understanding of the postsecular, is a dynamic and ongoing process.

Due to these various complexities in the notion of translation, it may be more effective to talk of translation strategies, to indicate its enduring, active, and site-specific nature. Just like the notion of the postsecular in general, this process of translation is not an impersonal abstraction, but a dynamic of negotiations back and forth, as performed by individuals on the ground. Taking the described complexities of translation into account, three strategies are of particular interest to a postsecular understanding of artistic practices. Each strategy is illustrated by one example from the field.

3.1.1 Reformulation

A first, very prevalent translation strategy is that of reformulation. Departing from traditional contexts, religious institutions are actively searching for, on the one hand, new *modes* of communication and, on the other hand, for new *means* of communication. This search for new vocabularies and instruments to express sacred imaginaries in transforming realities can be well illustrated by the Vatican participation in the Venice Biennales of 2013, 2015, and 2018.

Building on its vast heritage, the Vatican announced in 2008 it was going to participate with a national pavilion in the Venice contemporary art biennale. It took five years before the first pavilion was realized in 2013, reflecting the Vatican's wish, as it was officially formulated, to fix the broken marriage

between art and faith.[99] Artist collective Studio Azzurro, photographer Josef Koudelka, and painter Lawrence Carroll were invited to show work in response to the overall pavilion theme of Creation. While thematically the 2013 pavilion drew from Genesis books 1–11, the way the pavilion was presented to the outside world drew heavily from the secularization narrative. The pavilion was presented as a response to a world in which religion was drawn to the margins, while the artistic process was seen as an essentially spiritually invested activity.

Simultaneously, the official commissioner of the pavilion, Cardinal Gianfranco Ravasi, was very clear about the type of art that could and could not be presented in the pavilion. As he stated in the catalogue, "From the beginning we have tried to avoid the risk of proposing a vague spiritual art which leans toward a sort of New Age religiosity. And we tried also to avoid presenting works destined explicitly for worship and so responding to the specific canons of Catholic liturgy."[100] This distinction was reinforced by the pavilion's curator, Micol Forti,

> For Cardinal Ravasi, it is very important to distinguish between religious and liturgical artwork and that which engages with spiritual ideas. The Sistine Chapel is a church: it contains completely revolutionary artworks but it is still a church. [The Holy See Pavilion] is not a church; this is a completely different context. We respect this context: it is a place for international art from different contexts, philosophies, culture and religions.[101]

Their takes on the pavilion reflect how boundaries were created, with a clear sense of what should be avoided. It shows an attempt to please two sides: the religious institutional side, respecting the religious heritage and traditional framework, from which the commissioning took place; and the side of the contemporary art world, respecting and promoting artistic integrity and artistic freedom of expression.

These considerations combined and resulted in artworks greatly varying in discipline, material, and approach to the overall theme, but which by no means overtly referenced religious symbolism. That iconography was privileged for

99 Gianfranco Ravasi. 2013. "La Santa Sede alla Biennale" in Micol Forti and Pasquale Iacobone (eds.). *In Principio. Padiglione della Santa Sede. 55. Esposizione Internationale d'Arte della Biennale di Venezia 2013* (Bologna: FMR-ARTE' spa) 15.
100 Idem, 26–27.
101 Charlotte Higgins. 2013. "Vatican goes back to the beginning for first entry at Venice Biennale," in *The Guardian*, 31 May. https://www.theguardian.com/artanddesign/2013/may/31/vatican-first-entry-venice-biennale.

liturgical rituals and the sacred spaces designed for these rituals. Rather the works in the Biennale pavilion engaged with the Biblical theme of creation on a more conceptual level, relating the themes to topical issues and creating new forms of spiritual engagement.

In 2015, the pavilion hosted works by digital artist Monika Bravo, installation artist Elpida Hadzi-Vasileva, and photographer Mário Macilau, in response to the theme 'In the Beginning, the Word became flesh.' While the first pavilion had been greatly anticipated by international media, the second edition rarely received attention. The novelty seemed to rather lie in the Vatican's participation, and the question of whether the participating artists were religious themselves, than in the particular artworks its pavilion displayed.

The critical response was notably different when the Vatican decided not to participate in the following art biennale, but to join the 2018 architecture Biennale instead. For that participation, acclaimed architects were asked to create a design for a chapel, ten in total. The only two requirements in the design were the presence of an altar and a pulpit. With Pritzker-prize winner Norman Foster participating, the Vatican pavilion was bound to receive international media attention. This happened also due to the fact that the Vatican was the only pavilion that constructed the designs, rather than presenting drawings and scale models as the architecture pavilions usually do. This, in combination with the quality of the designs, led the *New York Times* to call it, "the most surprising entry in Venice's architecture biennale."[102]

The Vatican's negotiations between its heritage, liturgical spaces, and symbolism seemed to have effectively worked in the form of architecture. In the meantime, the installation of Studio Azzurro, from the first arts pavilion, has been officially included in the Vatican Museum's collection, as the first video work in this collection ever.[103] In its efforts to become more visible in a perceived secular part of the world, the Vatican has also invited some secularity back into its own institutions.

3.1.2 Ludification

A second translation strategy can be identified as ludification, or playful appropriation, the phenomenon of ludic citations and transformations of religious imagery. As Johan Huizinga famously posited the notion of the 'homo

102 Elisabetta Povoledo. 2018. "The Most Surprising Entry in Venice's Architecture Biennale? The Vatican's," in *New York Times*, 25 May. https://www.nytimes.com/2018/05/25/arts/design/venices-architecture-biennale-the-vatican.html.

103 The Vatican Museum's press release about this new addition to the collection: http://www.museivaticani.va/content/museivaticani/en/eventi-e-novita/iniziative/SpazioIncontro/2016/la-videoarte-fa-il-suo-ingresso-nei-musei-del-papa.html.

ludens,'[104] scholars across disciplines speak of a ludic turn or even a global ludification in contemporary culture.[105] Resulting from technological advancements, facilitating new forms of individual and collective engagement, play permeates both entertaining and serious fields of daily life and societal structures. Forms of play can be found in activities ranging from Internet games and TV shopping to work processes, education, and politics.[106] With such omnipresence of playfulness in numerous cultural phenomena, it may be no surprise that religion does not escape this trend. Andre Droogers has theorized play as an essential human faculty, as a feature of how people essentially deal with their realities.[107] On an individual level, people try on features of religious identities, mixing and matching their own identity, drawing from various traditions, finding a mode that fits their individual needs at a specific moment in time and place. This mixing and matching is an ongoing process, which may result in varying outcomes through one's lifetime.[108]

This tendency can also be found in the arts. Artists have the power and freedom to place visualized narratives such as The Last Supper or Christ's crucifixion, iconic religious figures such as Mary or the Buddha, or sites like the Kaaba or the Sistine Chapel in new contexts. Such appropriations question long-established meanings and have the ability to attribute new, contextualized, and diversified meanings through the imagery they draw from. Such re-contextualization is often in need of a sense of playfulness, allowing some breathing space for new negotiations about semantics. There is a paradox to such semantic negotiations from a postsecular perspective. On the one hand, they are often deemed necessary because the traditional iconography on its own becomes less and less meaningful for younger generations that are not necessarily raised in a particular religious tradition. On the other hand, drawing from traditional iconography is thought to communicate something universal and to provide the newly created work with a sense of authority and power.[109]

104 Johan Huizinga. 1949. *Homo Ludens: A Study of the Play-Element in Culture* (London: Routledge and Kegan Paul).
105 Valerie Frissen et al. (eds.). 2015. *Playful Identities: The Ludification of Digital Media Culture* (Amsterdam: Amsterdam University Press).
106 Idem, 9.
107 André Droogers. 2012. *Play and Power in Religion: Collected Essays* (Berlin: De Gruyter).
108 Ann Taves. 2013. "Building Blocks of Sacralities. A New Basis for Comparison Across Cultures and Religions" in Raymond F. Paloutzian and Crystal Park. *Handbook of Psychology of Religion and Spirituality* (New York, Guilford Press) 138–161.
109 Christiane Kruse. 2018. "Offending Pictures. What makes Images Powerful" in Christiane Kruse et al. (eds.). *Taking Offense. Religion, Art, and Visual Culture in Plural Configurations* (Paderborn: Wilhelm Fink) 17–58.

A cultural phenomenon that has been analyzed in terms of ludification is an event, annually organized since 2011 in the Netherlands on the Thursday before Easter, titled *The Passion*. In a 2017 article, scholars Mirella Klomp and Marten van der Meulen analyze this popular and highly mediatized event as a ludic ritualization of religion.[110] Every year, The Passion takes place on a public square in the heart of a Dutch city. Interestingly, to this date no city in the traditionally catholic south has hosted the event. So far, The Passion was staged in the cities of Gouda (2011), Rotterdam (2012), The Hague (2013), Groningen (2014), Enschede (2015), Amersfoort (2016), Leeuwarden (2017), and Amsterdam (2018). In 2019 The Passion took place in the city of Dordrecht, on the occasion of the 400th anniversary of the Synod of Dordrecht.

The event consists of several elements: a narration of the passion story based on the gospels, the performance of popular Dutch songs by famous actors and singers taking on the roles of the various characters in the passion story, and a procession with a giant lit cross through the streets of the city, ending up at the event stage at the moment the story has come to Christ's crucifixion. The event is aired on prime-time television and lasts about eighty minutes. The format is based on the 2006 event of the Manchester Passion, was bought and developed by a TV production company, and further developed in collaboration with the two Dutch Christian broadcasting companies. While the live-event is attended by thousands of visitors, the televised version is also extremely popular. In 2015, The Passion attracted a record-number of 3.8 million viewers, numbers usually only attained by world-cup matches of the Dutch soccer team or registrations of events with a profoundly national character.[111]

In terms of translation, two elements are of interest here. First, the popular Dutch songs are a means of translating parts of the traditional passion narrative into a non-religious vocabulary. Many of the songs are known to a broad audience, even though the selections of widely known songs becomes more and more difficult each consecutive year. There is only one song that reappears in every new edition, while all the other songs are different. As Klomp and Van der Meulen observe, the producers "put the lyrics [of the songs] into the mouths of the main characters. A love song of a couple sounds different when sung as a duet by Jesus and Judas: such a song is imbued with a new and/or different meaning, giving it an extra layer."[112] And not only the song

110 Mirella Klomp, Marten van der Meulen. 2017. "The Passion as a Ludic Practice—Understanding Public Ritual Performances in Late Modern Society: A Case Study from The Netherlands," *Journal of Contemporary Religion* 32.3: 387–401. DOi: 10.1080/13537903.2017.1362879.
111 Idem, 387.
112 Idem, 392.

itself is attributed with a new meaning, also the events described in the passion narrative to which the song relates, are provided with a new vocabulary. The translation process occurring during this event is reciprocal here. It gives the producers a sense of freedom to experiment, or play if you will, with the selection of the songs, their lyrics, and transformations of meaning.

Second, ludic aspects can be found in the choice of actors and singers performing the different characters in the narrative. While the leading roles are usually performed by professional singers and actors, the selection for the extras provides room for playful connections between the characteristics of the part and topical events in everyday life. Most notably is the role of Barabbas, which is kept secret as long as possible. While all the other roles are announced during the weeks leading up to the event, the (small) part of Barabbas is performed by someone who in real life has been subject to public debate. In previous editions, the role has been taken up, for example, by Dave Roelvink (2015), who at the time was facing charges for theft and his role in a sex tape scandal, and by Yuri van Gelder (2017), an athlete with a past of addiction, who was expelled from Olympic participation after he disobeyed the behavioral codes of conduct of the national Olympic team while being in Rio de Janeiro.

There tends to emerge a public debate about the participation of these figures, due to the question if they are deserving of a national platform following their behavior in real life. But it is exactly this behavior that got them the part in the first place. In an official response to the public debate about Roelvink's participation, the organizers stated that, "Exactly by giving this role to Dave and the resistance that this evokes, The Passion shows the injustice/ unfairness of the fact that Jesus was condemned instead of Barrabas [sic]."[113] Arguably, it is this intertwinement between aspects drawn from religious traditions and topical references to public life that makes The Passion a success in The Netherlands.

While the 2006 Manchester edition was a one-off event, in 2016 The Passion was staged in the United States. It was a co-production between the two organizing Dutch broadcasting agencies and the American broadcaster Fox.[114] The character of the event, held in New Orleans, was remarkably different from the Dutch version. For example, with Tyler Perry as narrator, the style of narration and the public response elicited by this style turned the event into a kind of open-air faith service rather than a musical spectacle. It goes to show how

113 The statement was published on Facebook, on 1 April 2015. Cited and translated in Klomp, Van der Meulen, *The Passion as Ludic Practice*, note 19.
114 The registration of the event can be found here: https://www.youtube.com/watch?v=EHnoijTE4zw.

postsecular entanglements are strongly context-specific and in need of empirical research in order to make analytical sense of them.

3.1.3 Re-presentation

A third translation strategy that can be identified in contemporary culture is that of re-presentation, or the reframing of religion and religious heritage. This strategy takes the heritage as it is, without the intention of transforming it into a new constellation. Instead, this strategy results from the acknowledgement that a continuously changing society needs transformed ways of seeing its own heritage. It consists of ways to create new entry routes into the existing heritage, by emphasizing other features than the religious characteristics.

While museums have been showing religious artifacts since their very beginning, a turn in perception is notable. Religious sites are increasingly organizing exhibitions or adding contemporary works to their liturgical spaces. UK churches are an interesting example here. For instance, Salisbury Cathedral has an annual exhibition program, for which a special arts curator has been appointed. St. Paul's Cathedral commissioned American artist Bill Viola the first-ever video artwork to be added to a British Cathedral site, which resulted in the four-screen piece *Martyrs* (2014), joined by the piece *Mary* in 2016. Or Winchester Cathedral, which has commissioned works from Henry Moore and Anthony Gormley, and presents these as part of the church's modern art collection. While museums have been long seen as new churches, this development returns the question: can churches be the new museums?

A fascinating example in response to this question, also from The Netherlands, is a campaign launched in 2017, titled *Het Grootste Museum van Nederland*. Literally translated, this means 'The Largest Museum of The Netherlands,' but the organization officially translated it into 'Dutch Museum Churches.'[115] So, while the Dutch name does not include the term 'church,' it was retained in the English translation. This marketing campaign literally frames religious sites as museums, online and in large posters advertised around the country. In 2017, this campaign consisted of a selection of eleven churches and two synagogues. In 2018, three more church sites were added to the collection. Departing from the question why it is perfectly normal to visit religious sites when on a holiday abroad but not in one's own country, this campaign intends to draw attention to the rich presence of religious heritage in The Netherlands. This does not occur predominantly by focusing on the sites as churches, but

115 The project's English language website can be found here: https://www.grootstemuseum.nl/en/.

by presenting the sites as guardians of paintings, architecture, and artifacts—indeed by presenting these sites as museums.

Presented as guardians of art and heritage, all sites are still in use as places of worship for religious communities. Additionally, the doors are opened for visitors who can come and take in the architecture, art, and general atmosphere. In addition to the marketing features, the campaign consists of audio guides that are handed out at the locations. These audio guides illuminate the building's history and aesthetic features, the artworks it houses, and other types of historical information. During the first year of the campaign, about 100.000 visits were paid to the various sites, considered a successful start to this program.[116]

The translation process that takes place here is seemingly of Habermassian nature. A selection of religious sites is presented in secular terms: from church and synagogue to museum. The question is what the added value is of performing this translation strategy. What does it imply when a religious site is presented, and interpreted, as a museum? The International Council of Museums drafted the following definition of a museum: "A museum is a non-profit, permanent institution in the service of society and its development, open to the public, which acquires, conserves, researches, communicates and exhibits the tangible and intangible heritage of humanity and its environment for the purpose of education, study and enjoyment."[117] This means that the participating churches and synagogues in this program are not only sites of worship, but also want fulfill a role of promoting and facilitating education, study, and enjoyment. They wish to, and can, function at the service of the development of the society in which they are located. This occurs through advertising and making accessible the material and immaterial religious witnessing of humanity throughout time.

Within the Dutch Museum Churches project, the churches and synagogues—and all the artifacts and histories they house—are considered as collection pieces. Together they form one large, combined collection, which can be expanded or reduced over time. The documentation, presentation, and research, as mentioned in the ICOM definition, occurs on the instigation of the mothership: Museum Catharijneconvent in Utrecht, the Dutch museum for Christian art and heritage of The Netherlands. The campaign questions and challenges not only the definition of a museum, but also the general perception

116 Press Release, 21 June 2018.
117 http://archives.icom.museum/definition.html. In December 2018, a procedure was launched for a revision of the museum definition. https://icom.museum/wp-content/uploads/2019/01/MDPP-report-and-recommendations-adopted-by-the-ICOM-EB-December-2018_EN-2.pdf.

of what a house of worship entails and how it can function in a fluid and diversifying society. Given the fact that this is a fairly recent initiative, I hope more research will be done on the societal effects—for both the religious heritage and its audiences—of projects like these, not only in national but also in international comparative perspective.

The three translation strategies as described here occur in response to the long-dominant secularization narratives, as a reply to the conviction that institutionalized forms of religion are of less importance and relevance to contemporary citizens than in pre-modern times in which many of these institutions flourished. While the search for religion or spirituality itself may not have diminished or lost appeal (as will be explored in the next chapter), the traditional and institutional frameworks undeniably have. Artistic practices play a crucial role in the longing for a transcendent connection in an increasingly fragmented, fleeting, and virtualized world. Therefore, the framework of collectivity and connectivity that religious institutions intrinsically carry in them is something that can still be worthwhile. This may be seen as an argument in favor of engagement with translation efforts, rather than discarding of religious traditions and vocabularies all together. However, translation efforts can only work if they allow a process of continuous negotiation and are received in a mode of mutuality. The willingness for mutual understanding and presence is key in a diversified landscape, albeit of religious, cultural, or political nature.

3.2 *Liquid Boundaries*

Zygmunt Bauman has famously characterized modern societal structures as 'liquid.'[118] Authorities are questioned, jobs are no longer inherited from one familial generation to the next, and identities are flexible. Transforming, changing, and individually construed identities replace those prescribed by collectivities and institutions. "In the brave new world of fleeting chances and frail securities, the old-style stiff and non-negotiable identities simply won't do."[119] In terms of ritual and liturgical practices this has been theorized by means of the notion of 'bricolage,'[120] describing a transition in perception of ritual practices and a changed conception of liturgy. Turning from a one size fits all to a more context specific approach; such ad-hoc and mixed practices continue to be meaningful exercises.

118 Zygmunt Bauman. 2000. *Liquid Modernity* (Cambridge: Polity Press); Zygmunt Bauman. 2005. *Liquid Life* (Cambridge: Polity Press).
119 Zygmunt Bauman. 2004. *Identity: Conversations with Benedetto Vecchi* (Cambridge: Polity Press) 27.
120 Marcel Barnard, et al. (eds.). 2014. *Worship in the Network Culture: Liturgical Ritual Studies. Fields and Methods, Concepts and Metaphors* (Leuven: Peeters Publishers) 117–130.

When it comes to religious identification processes, this has recently been termed as 'multiple religious belonging.'[121] Individuals create their own, personalized rituals, drawing from traditionally incompatible religious traditions and liturgical practices, turning it into meaningful, even sacred, practices for themselves. "Discussing and communicating identities becomes more important when in the current phase of liquid modernity identities are undermined. Identities are sometimes temporarily fixed, but are lighter than traditional identities and can be changed more easily."[122] Drawing from observations of how people live everyday life and seek for practices to embody set-apart meanings, such theoretical approaches are acknowledgements of non-institutionalized, situational, yet valuable forms of ritualization and sacralization.

In line with Bauman's characterization of the modern world as liquid, Gordon Lynch described contemporary sacred formations in terms of a fragmentation of the sacred. Lynch defines the sacred as "a way of communicating about what people take to be absolute realities that exert a profound moral claim over their lives."[123] By departing from the observation that forms of communication constitute constructions of the sacred; Lynch provides a direction for the analysis of the individual components of these communicative forms. "They typically focus on specific symbols, invite people into powerful forms of emotional identification, and are made real through physical and institutional practices."[124] Looking at these components allows for understanding the underlying dynamics of these sacred forms.

The communicative forms that Lynch takes to constitute the sacred have a particularly powerful potential. He regards the sacred as a cultural force that has transformed over time. Lynch designated pre-modern conceptions of the sacred as 'imperial sacred,' of which moral claims were provided with universal legitimization via an institutionalized authority. Symbolic language, of which meanings were established, could easily communicate these claims and through imperial efforts be disseminated beyond geographical boundaries. This developed into a modern conception of the sacred, which Lynch calls the 'fragmented sacred.' Here are no universal models of morality, prescribed authority, and fixed symbolic meanings. Rather, that which is embedded with ultimate and non-negotiable, hence sacred, value, results from negotiations

121 A project at the Free University in Amsterdam is dedicated to the notion of Multiple Religious Belonging. https://clue.vu.nl/en/projects/current-projects/Multiple-religious-belonging/Multiple-religious-belonging.aspx.
122 Kees Terlouw. 2009. "Rescaling Regional Identities: Communicating Thick and Thin Regional Identities," *Studies in Ethnicity and Nationalism* 9.3: 452–464.
123 Gordon Lynch. 2012. *On the Sacred* (Durham: Acumen) 11.
124 Idem.

based on abstractions and ideas. These, in turn, function as a foundation on which social structures are built and to which moral behaviors are related and tested. This fragmented dynamic is representative for the current liquid world, in which meanings are continuously negotiated, construed, and re-construed.[125]

Notions like bricolage, multiple belonging, and fragmentation offer incredibly fruitful resources for artistic practices relating to the sacred, which have always served the possibility of transgressing boundaries and exploring uncharted cultural territory. To characterize the globalizing nature of the contemporary art world, S. Brent Plate coined the term 'iconomash.' The term responds to Bruno Latour's famous notion of 'iconoclash,' indicating the problematic and complex nature of co-existing religious visual imaginaries in secularized settings.[126] Rather than emphasizing the problematic nature of the intertwinements of religion, the secular, and the arts, Plate wants his term to reinforce the uncharted creative territories of opportunity to mix and match.

Iconomash indicates how a "sense of otherness and Otherness will be depicted in light of, in response to, and in conjunction with various religious traditions that currently co-exist."[127] Erika Doss summarizes iconomash as, "the morphing of pluralistic, synchronistic, and multi-cultural spiritual perspectives and art-making processes. Modern and contemporary artists draw on religious inspirations, practices, and rituals from all over the world,"[128] demanding new modes of investigation from scholars in the academic field of religion and the arts. As a concept, Plate stipulates, iconomash is drawn from "the lived pluralisms on the streets of regions around the world: from New Delhi to New York, from York to Dubai."[129] As such it emphasizes that an interpretative framework based on Christian, and 'particularly Protestant' conceptions of art, iconography, and symbolism 'are grossly uninformed.'[130]

In globalized and diversified societal structures, western Europe's Christian roots are as much joined by, as questioned and challenged by other religious and non-religious configurations. This reframes the perception of majority and minority religious identities, demanding a methodology that relates not to just one religious tradition, but allows for incorporation

125 Idem, 49–67.
126 Bruno Latour. 2002. "What is Iconoclash? Or is There a World beyond the Image Wars?" in Peter Weibel and Bruno Latour (eds.). *Iconoclash, Beyond the Image-Wars in Science, Religion, and Art* (Karlsruhe, Cambridge: ZKM, MIT Press) 14–37.
127 S. Brent Plate. 2009. "From Iconoclash to Iconomash" in James Elkins and David Morgan (eds.). *Re-Enchantment* (New York, London: Routledge 2009) 210.
128 Doss, *The Next Step?*, 299–300.
129 Plate, *From Iconoclash to Iconomash*, 210–211.
130 Doss, *The Next Step?*, 299–300.

of multiple religious imaginaries, relating to one another on an equal level. However, when looking at the field of artistic practices, the line between iconomash and iconoclash remains fine and tricky—especially when the artistic practices relate to a mixing and matching of Islamic elements (both aesthetic and religious) in secularized contexts with Christian roots.

A notable example is the Icelandic pavilion for the 2015 Venice Biennale of contemporary arts. Whereas it was the second time the Vatican participated in the Biennale, the Icelandic contribution consisted of the installation and operation of a temporary mosque. Under the title *The Mosque: The First Mosque in the Historic City of Venice*, artist Christoph Büchel intended to address the discrepancy between Venice's long historic connections with the Islamic world, the several thousands of Muslims living in Venice, and the city council's consistent refusal of ever having an official mosque erected within the city's grounds.[131] Described by a journalist as a test to Venice's tolerance,[132] the temporary mosque was to be installed in the historic church Santa Maria della Misericordia. This church is part of the neighborhood that also houses the historic Jewish ghetto. The church building dates back to the tenth century, was renovated in 1864, but has been closed since the second half of the twentieth century and privately owned since 1973. During the Biennale period, the mosque was to become an active place of worship, adjoined by a program of educational and cultural activities for the wider audience.

The project was organized in collaboration with the Muslim communities in both Iceland and Venice. Announcing the project, Icelandic Minister of Culture Illugi Gunnarsson stated,

> In recent decades Iceland has been enriched by immigration from all over the world, stimulating a creative dialogue on various issues, based on the religious tolerance upon which our society puts great emphasis. The Muslim Community in Iceland is an important voice in this dialogue, and it is my hope that the Icelandic contribution of *THE MOSQUE* to La Biennale di Venezia 56th International Art Exhibition, initiated by Christoph Büchel, will be a positive contribution to this dialogue on the international stage.[133]

131 For a full description of the project, see: http://www.biennialfoundation.org/2015/05/project-initiated-by-artist-christoph-buchel-in-collaboration-with-the-muslim-communities-of-venice-and-iceland/.
132 Randy Kennedy. 2015. "Mosque Installed at Venice Biennale tests City's Tolerance," *New York Times*, 6 May. https://www.nytimes.com/2015/05/07/arts/design/mosque-installed-at-venice-biennale-tests-citys-tolerance.html?module=inline.
133 Idem.

The President of the Muslim Community of Venice, Mohammed Amin Al Ahdab, reinforced his hope for the lasting effect of the art project in his city,

> Recently, several encouraging signs of openness and understanding have come from the government of our city, from local authorities both civic and religious. But through its depth, truth, and wisdom, the Biennale project of our Icelandic friends is the greatest indicator thus far that a bright new page can be written into the history of the City of Venice through a new form of art—art that is not limited to painting and sculpture only, art that needs today all the way, the art of dialogue.[134]

Al Ahdab's remarks about the nature of art, in relation to religion, have significant implications. He classifies 'the art of dialogue'—implying a form of inter-religious dialogue between the Muslim community, the traditional Catholic roots of the Venetian community, and the secular city council—as a performative art form. Yet, his hope, and that of the artist's intentions, turned out to be misplaced.

Within days of the opening of *The Mosque*, Catholic authorities expressed their dissatisfaction with the project. Despite the fact that the church building was desacralized and privately owned, the Patriarchate of Venice communicated in a statement, "For any use other than Christian worship, authorization must be sought from the ecclesiastical authorities, regardless of who is the owner of the church. Such authorization, for this site, was neither requested nor granted."[135] Two weeks after its installment, the Venetian police shut down *The Mosque* for reasons of security, over-population inside the building, and the organization not having obtained the proper permits beforehand.[136] Rather than functioning as a platform for dialogue, the art project evoked extreme responses, arguably for presenting worship as an art form, and for 'iconomashing' the Catholic building with Islamic practices within the context of secular art biennale. Venice, under the guise of bureaucratic rules and procedures, nor the international art community, as no collective protest was staged, proved ready for this intertwinement in 2015.

134 Idem.
135 Randy Kennedy. 2018. "Officials in Venice Challenge Mosque Installation at Biennale," *New York Times*, 8 May. https://www.nytimes.com/2015/05/09/arts/design/officials-in-venice-challenge-mosque-installation-at-biennale.html?module=inline.
136 Randy Kennedy. 2018. "Police shut down Mosque Installation at Venice Biennale," *New York Times*, 22 May. https://www.nytimes.com/2015/05/23/arts/design/police-shut-down-mosque-installation-at-venice-biennale.html.

Büchel's re-imagination of what art is and can be, what religion is and can be, and how these dimensions relate to one another in new configurations, constituted of conceptions seemingly too fluid for this liquid time and place. However, such imaginaries are continuously tested and expanded by means of artistic practices, resulting not only in shutdowns, but also in putting societal and cultural issues on public agendas and in individual hearts and minds—which is certainly of relevance to a postsecular understanding.

3.3 *Alternative Imaginaries*

While Büchel's mosque project proved too strong a confrontation between the arts, religious practices, and societal context, generally religious traditions continue to provide artistic sources of inspiration. And as Plate's notion of iconomash intends to indicate, due to processes of globalization, artists can take the freedom to mix and match iconic imagery, theological notions, and everyday experiences into new constellations. Art museums, in their aim of serving as socially inclusive and representative public institutions, can no longer contain religion and box it to the side. In Western Europe, a prominent aspect of negotiations of postsecular social realities is the creation of a presence for Islamic arts and histories in art museums. Art's functioning in global and postcolonial configurations has strong political implications for artistic practices, museums' modes of selection and display, and public reception.

In the contemporary writing of self- and collective narratives in European countries with a historically and culturally Christian character, Islam has a contested but inevitable position. Commissioning or displaying artistic responses to Islamic heritage form a strategy for museums to deal with this topic. In collaboration with Art Jameel, a philanthropic branch of the globally operating Jameel family's business empire based in Saudi Arabia, the Victoria & Albert Museum in London launched the biannual Jameel Prize in 2009. The prize has an international scope and shortlists artists who create "contemporary art and design inspired by Islamic tradition. Its aim is to explore the relationship between Islamic traditions of art, craft and design, and contemporary work as part of a wider debate about Islamic culture and its role today."[137]

Located in adjacent exhibition halls, the exhibition of the Jameel Prize nominees forms a contemporary counterpart to the more historically oriented Jameel Gallery of the Islamic Middle East. This gallery was opened in the Victoria & Albert Museum in 2006 and displays highlights from the museum's

137 Jameel Prize 5, Website Victoria & Albert Museum, London. https://www.vam.ac.uk/exhibitions/jameel-prize-5

Islamic collection.[138] While the Jameel Prize features living artists and shares their insights about Islamic culture and spirituality through the display of their work, the historic gallery displays, as John Reeve observed, "the objects as a series of safely distanced art forms, [suggesting] (...) reservations about presenting Islam as a living faith, today and in the past."[139]

The several Jameel Prize exhibitions to this date feature artists who draw from Islamic aesthetics, such as geometric forms and calligraphy, from traditional crafts, such as weaving and embroidering, or who express a sense of spirituality through modes such as reflection or meditation. Many of the works reflect not only on Islamic traditions, but even more so on their position in today's globalized and postcolonial world.

Jameel Prize 5, the 2018 edition, contained work by Hayv Kahraman, an Iraqi-born, Los Angeles based artist, from her series *How Iraqi are you?* (2014–16). The paintings consist of a combined visual language based on Arabic calligraphy, manuscript illuminations, and Asian women's portraits, portraying autobiographical memories of her familial migrant history. Kahraman's visual and linguistic semantics reflect a globalized, disenfranchised perspective. As she recounts, "I can now see these Arabic letters from the perspective of an American or a Swede, and that terrifies me. It makes me want to reiterate them, paint them, write them, re-learn them and re-memorize them."[140] Kahraman's experience embodies the complexity and pluriformity of contemporary globalization in a very personal and autobiographical visual manner.

Another featured artist in the Jameel Prize 5 exhibition, Kamrooz Aram, born in Iran and based in New York, relates such experiences of disenfranchisement to institutional practices.

> One of the things that is interesting about Islamic art is the ways in which people, like myself and the so-called diaspora, are engaging with it. I have lived in Isfahan and Tehran before we moved to the US and so I am familiar with the mosques of Isfahan. However, most of my experience has to do with the kind of eeriness of going to the Metropolitan Museum of Art in New York City and seeing a mihrab from Isfahan.[141]

138 Reeve, *A Question of Faith*, Chapter 9.
139 Idem.
140 Octavio Zaya. 2015. "Are we not all Foreigners?," Website Hayv Kahraman. http://www.hayvkahraman.com/2017/01/21/are-we-not-all-foreigners-octavio-zaya/.
141 Interview with Kamrooz Aram, for Jameel Prize 5. https://www.youtube.com/watch?v=gKlUearMV1E.

With his art installations, Aram wants to confront the viewer with the ways in which exhibition design shapes understanding of the displayed objects. He conveys how Western museum practices, rooted in appreciation of modernist formalism, primarily present Islamic art for its decorative qualities. By investigating design and display mechanics, Aram simultaneously draws attention to the historically invested meaning to such objects and their contemporary functioning in their new contexts. He combines paintings, objects like pottery or tiles, and pedestals to explore the impact of presentation strategies and how they are mutually dependent in creating the contemporary appreciative framework.

Not only artists, but museums themselves also question the implications of their practices and use these as a mode of communication. In February 2017, the Museum of Modern Art in New York disrupted its collection display in response to an executive order on immigration (colloquially called the "Muslim travel ban") installed by President Trump.[142] Preventing citizens from several Islamic countries to (re-)enter the country, a widespread public protest emerged inside and outside of the United States. The Museum of Modern Art decided to hang works of art, created by artists originally from the countries subjected to the ban, center stage. Its routing along art historical icons, which had received critical attention from Carol Duncan as discussed in the previous chapter, was seriously shaken up. Work of Zaha Hadid appeared next to Jean-Jacques Rousseau, a sculpture by Parviz Tanavoli was placed in the Italian Futurism gallery, and a video of Tala Madani was paired with German Expressionist Ernst Ludwig Kirchner. While societally engaged art is no stranger in contemporary art museums, this type of political statement, conveyed through museum practices itself, is a rare phenomenon in modern art museums.

Politics are also present in ongoing debates about ownership. In addition to postcolonial restitution questions, authority and knowledge production are no longer features exclusively located with museum curators. Rather communities owning or using the type of objects that are part of museum collections are increasingly consulted on modes of display and contribution of knowledge, via for instance focus groups with community representatives.[143] As such,

142 Jason Farago. 2017. "MoMA Protests Trump Entry Ban by Rehanging Work by Artists from Muslim Nations," *New York Times*, 3 February. https://www.nytimes.com/2017/02/03/arts/design/moma-protests-trump-entry-ban-with-work-by-artists-from-muslim-nations.html.

143 Reeve, *A Question of Faith*, Chapter 9.

expertise is found in the communities, acknowledged through incorporation in exhibition mechanisms, and in turn shared with a broader public. As Simona Bodo argues, "there is a pressing need for strategies and programs aimed at creating 'third spaces,' where individuals are permitted to cross the boundaries of belonging and are offered genuine opportunities for self-representation."[144]

The importance of crossing boundaries and expanding conceptions of self-representation are reinforced by several scholars in religion and the arts. Doss argues for a broader understanding of both art and religion. "Theorizing the subjects of modern art and religion begins with discarding limiting assumptions about both—especially those that insist on their binary opposition—in favor of more relevant, and critically ambitious, considerations of the felt life of faith, the material and visual dimensions of piety, and the affective dynamics of art."[145] In addition, Gordon Graham argues for a diversification of the purposes for which the term art is employed. In an acknowledgement of how aesthetics permeate daily life on an endless amount of ways, he poses the question where it gets us if we call the objects in a museum 'art,' yet the objects in our houses 'design.'[146]

For scholars of religion and the arts, an expanded conception of art leads to numerous fields of interest: music, theatre, film, advertising, and fashion, to name a few. Over the last decades, fashion exhibitions have become extremely popular. The Metropolitan Museum of Art (MET) in New York organized the exhibition *Heavenly Bodies, Fashion and the Catholic Imagination*.[147] Divided over three museum galleries and its uptown space at the Cloisters, the MET organized the exhibition in collaboration with the Vatican. Their loaned liturgical objects were staged amongst medieval and gothic architecture and fashion items from the seventeenth century till the present. Amongst others, the exhibition created a parallel between contemporary fashion shows and the rituals and ceremonies of the Catholic liturgical year.[148] The accompanying

144　Simona Bodo. 2012. "Museums as Intercultural Spaces" in Richard Sandell and Eithne Nightingale (eds.). *Museums, Equality, and Social Justice* (New York: Routledge). E-book: Chapter 13.
145　Doss, *The Next Step?*, 298.
146　Graham, *Philosophy, Art and Religion*, Chapter 6.
147　The exhibition ran between 10 May—08 October 2018 and attracted over 1.4 million visitors, making it the MET's best viewed exhibition ever.
148　Carly Daniel-Hughes. 2018. "Sexy Celibates and unmanly men?," *Immanent Frame*, 19 October. https://tif.ssrc.org/2018/10/19/sexy-celibates-and-unmanly-men/?fbclid=IwAR1wuIum6boiyUlKnJD5N_7WnrCavMpC9HimyPVAKPND5F2khTNLrKCpwow.

MET Gala, inspired by the exhibition theme, saw numerous celebrities showing high-fashion interpretations of Catholic imagery and vestments.

The exhibition and the gala embodied all sorts of translation strategies between the Catholic tradition and the world of fashion. Yet, the gala, with its red-carpet ritual of staging photo opportunities, demonstrated a danger to translation of this kind. Extrapolating on the observations of Kamrooz Aram about Islamic art objects as mere decoration: when religious objects are unhinged from their content and significance, all that remains is appearance. In the case of fashion, religion then, quite literally becomes a pose. Which is in turn a strategy employed by many a celebrity in music videos, album covers, and stage designs.

The religious pose has proven time and again powerful, exerting significant commercial potential. In high-fashion design itself, this is seen in the Dolce & Gabbana Fall 2013 line referencing Byzantine mosaics in the Cathedral of Moreale or the visionary representations of God by William Blake on a pair of Dr. Marten's boots. But it is also seen in the overall purpose of marketing, as religious imagery and references are regarded as powerful.

A notable example is the fall advertisement campaign of the menswear company Suitsupply in 2018–19. After previous provocative campaigns pivoting on themes of sexuality and gender, this campaign was simply titled *Religion*. In the resulting imagery, male models of various ethnic backgrounds were set against backdrops referencing various world religions, in the company's attempt to celebrate diversity. "We feel it is important to showcase lifestyles that are representative of the Suitsupply global customer,"[149] the company's director stated. The Religion campaign follows one advocating same-sex love, which the director does not see as contradictory. "Releasing campaigns with polarizing topics is a consequence of conversing with our diverse customer base."[150] It is reflective of a fragmented, fluid nature of contemporary marketing logic.

The mechanics of exploration and expression of liquid boundaries, as has occurred for long in artistic practices, are increasingly sought after in the practices of art's institutional settings and the commercial fields surrounding them. This is a key characteristic of the postsecular: shifting meanings and boundaries, which not only result in conflict, but also in meaningful new configurations. In a world characterized by global migration, technological access, and the emergence of new diasporas, mixing and matching artistic and religious

149 Stephan Rabimov. 2018. "In Suits We Trust," *Forbes*, 01 October. https://www.forbes.com/sites/stephanrabimov/2018/10/01/in-suit-we-trust-fashion-meets-religion-at-suitsupply/#a2d06fi697ee.
150 Idem.

resources has become a prevalent phenomenon. This comes with the challenge of expanding existing conceptions of what both art and religion are, and can be. In the reformulation of these conceptions, the notion of spirituality has a crucial position, which brings us to the topic of the next chapter.

4 Spiritualization

In her introduction to the special section on Contemporary Art and Religion of the journal *Religion and the Arts*, Loren Lerner recounts how, despite the fact that not many contemporary artists explicitly express a religious affiliation, "there has been a resurgence of religious subject matter in contemporary art."[151] Drawing from the work of Jürgen Habermas, and philosophers in which he rooted his work like Jacques Derrida, Paul Ricoeur, and Julia Kristeva, Lerner then continues to present an extensive range of publications and exhibitions on the topic of art and religion. Her overview serves as empirical evidence for the engagement with the topic of religion in the fields of art history and art museums. The notion of spirituality has an omni-resent, yet ambiguous position in the discourse on religion in modern and contemporary art.

The first part of this chapter explores how the notion of spirituality has a significant position in attempts at reinterpreting the art historical canon. The scholarly reception of the spiritual in the work of Dutch painter Piet Mondrian is taken as an example of the ambiguous and pluriform nature of the subject. In addition to the study of individual artistic practices, the investigation of artistic movements or trends at large are also subject to a discursive battle over the spiritual. Romanticism is particularly of relevance here. Practices of many modern artists are rooted in Romantic notions about nature and the omnipresence of the spiritual. Such convictions and practices have much older counterparts in non-western parts of the world. The exchange of non-western art with Western Europe has in turn significantly impacted the contemporary perception of this work's spiritual qualities.

The second part of this chapter explores how art has been regarded as an alternative, substitute, or replacement of religion and its institutions. In response to the implications of such widespread and popularly believed observations, both artists and scholars have created an alternative interpretation: art has not replaced religion, rather art is regarded to constitute religion in itself. This conception of art reinforces the pluriform manifestations of religion

151 Loren Lerner. 2013. "Introduction: Special Section on Contemporary Art and Religion," *Religion and the Arts* 17: 1.

and spirituality in modern and contemporary artistic practices. The notion of spirituality has a strong sensory character, whether this relates to the artists making, or viewers looking at artworks. Scholars of art and religion follow suit with investigations into the aesthetic and sensational dimensions of religion's material culture and its immaterial implications.

The final part of this chapter looks into the spiritual potential of engagement with art, a topic that has received considerable interest over the past two decades. The paintings of Mark Rothko and its public reception are exemplary for this trend, both in academic scholarship and in museum practices. The spirituality invested by the artist is translated into the arts' potential spiritual effect on its viewers, which in turn impacts a global trend of museum practices. Several analytical attempts are explored that aim to unveil core elements of the spiritual in art and an experiential level of attention that can be characterized as spiritual. Furthermore, this section addresses the interest of art scholars in the ascetic dimensions of contemporary artistic practices, which affect not only the artists but, in contemporary performance practices, also the viewers. Here the performance art of Marina Abramoviç is taken as an example, an artist who also increasingly has begun to cultivate the spiritual in her work.

4.1 Acknowledging the Spiritual in Art

As mentioned in the introduction above, *The Spiritual in Art: Abstract Painting 1890–1985* is generally regarded as a landmark exhibition, focusing on the spiritual dimensions beyond the surface of geometric abstract, symbolist, and abstract expressionist art works. Staged in 1986 and 1987 in the Los Angeles County Museum of Art and the Gemeentemuseum in The Hague, the exhibition featured work of Wassily Kandinsky, Piet Mondrian, Hilma Af Klint, Paul Klee, Theo van Doesburg, Kasimir Malevich, and many others. In his opening essay to the catalogue Maurice Tuchman writes, "Abstract art remains misunderstood by the majority of the viewing public. Most people, in fact, consider it meaningless.... [However], artists made an effort to draw upon deeper and more varied levels of meaning, the most pervasive of which was that of the spiritual."[152] Tuchman describes the goal of the exhibition, and its accompanying catalogue, to demonstrate how the emergence of abstraction in western Europe and the United States was intricately linked to contemporary prevalent notions of late nineteenth and early twentieth century spirituality and how artists had been working with these ideas for the past hundred years.

[152] Maurice Tuchman. 1986. "Hidden Meanings in Abstract Art" in Maurice Tuchman et al. (eds.). *The Spiritual in Art: Abstract Painting 1890–1985* (New York: Abeville Press) 17–61.

The exhibition's main observation that, "their art reflects a desire to express spiritual, utopian, or metaphysical ideals that cannot be expressed in traditional pictorial terms," is directly followed by a confession: "Our idea is not new."[153] Tuchman departs from the work of art historians Arthur Eddy and Sheldon Cheney, who had published respectively as early as 1914 and during the 1920s and 1930s on how through their art, abstract artists were interested in expressing the spiritual.[154]

Tuchman's introductory words demonstrate a discrepancy that is still relevant a little over thirty years after the *Spiritual in Art* exhibition. In scholarship and museum practices, the sources of inspiration and intentions of modern artists are, and have been long, acknowledged to be of a spiritual nature. Yet, this acknowledgement does not seem to translate and catch on into the public perception, popular art historical writing, and dissemination to wider audiences. In these latter fields, the narrative of the public misunderstanding of abstraction and a general surprise about modern artists' spiritual engagements seems to persist. Or, at least that is how the narrative is framed time and again.

Take the example of Dutch painter Piet Mondrian, which is exemplary for this paradoxical tendency. In his own writings, published between 1917 and the early 1940s in a variety of sources,[155] Mondrian does not shy away from using the term 'geestelijk' (in English translated as *spiritual*, in German as *geistlich*). Departing from his interest in the theosophical writings of Helena Blavatzky and Rudolf Steiner, Mondrian developed his own terminology and visual vocabulary to give expression to the ideals he wanted to express with his art, achieving a form of spiritual harmony by means of unveiling the world's essential structures behind visible reality.[156] In 1963, Martin James published an article in which he argued for the importance of Symbolist notions for Mondrian's route to geometrical abstraction.[157] This argument was taken up and expanded by Sixten Ringbom in his 1966 article that explored the role of occult thinking in the overall emergence of abstraction.[158]

153 Idem. 17.
154 Arthur Jerome Eddy. 1914. *Cubists and Post Impressionism* (Chicago: McClurg); Sheldon Cheney. 1924. *A Primer of Modern Art* (New York: Boni & Liveright); Sheldon Cheney. 1934. *Expressionism in Art* (New York: Liveright).
155 Louis Veen (ed.). 2017. *Piet Mondrian, The Complete Writings* (Leiden: Primavera Press).
156 Jacqueline van Paaschen. 2017. *Mondriaan and Steiner: Wegen naar Nieuw Beelding* [Mondrian and Steiner: Paths to Neo-Plasticism] (The Hague: Komma, d'Jonge Hond).
157 Martin James. 1963–1964. "Mondrian and the Dutch Symbolists," *Art Journal* 23.2: 103–111.
158 Sixten Ringbom. 1966. "Art in 'The Epoch of the Great Spiritual': Occult Elements in the Early Theory of Abstract Painting," *Journal of the Warburg and Courtauld Institutes*, 29: 386–418.

In the catalogue of the 1971–72 Centennial Exhibition on the occasion of Mondrian's birthday, Robert Welsh argued for the explicit impact of Theosophy not only on Mondrian's intellectual development, but just as much on his actual style of painting.[159] In 2006, Marty Bax published her vast Ph.D dissertation that analyzes a widespread impact of Theosophy on Dutch culture in the late nineteenth and early twentieth century.[160] In the work of intellectuals, writers, architects, designers, and artists she recognizes Theosophical lines of inquiry. In the language used by Mondrian in his private letters and published texts, Bax uncovers a link with theosophical models of thinking. In the current state of Mondrian scholarship, the affinity with Theosophy remains a topic of scholarly interest—and its impact on his painting a point of heated debate.[161]

Alternative influences on Mondrian's spirituality have been explored as well. In 1994 Rosalind Krauss took a psychoanalytical approach to modern artists' creation of grids, of which she sees Mondrian's geometrical abstraction as an example. While formalist art history mostly discusses grids' formal features and material qualities, she argues, that in their own writings, "Mondrian and Malevich are not discussing canvas or pigment or graphite or any other form of matter. They are talking about Being or Mind or Spirit. From their point of view, the grid is a staircase to the Universal, and they are not interested in what happens below in the Concrete."[162]

Krauss argues how Mondrian's abstract paintings embody a dual position in the world, of simultaneous centripetal and centrifugal character.[163] The repetitive nature of their composition makes the paintings a fragment of an implied larger whole; simultaneously, one painting embodies a relation between the visible world and the cosmos, embodying this larger whole all at once. In the establishment of this connection, as intended by Mondrian, lies art's fundamental spiritual nature. It leads Krauss to observe, "I do not think it is an exaggeration to say that behind every twentieth-century grid there

159 Robert Welsh. 1971. "Mondrian and Theosophy" in *Mondrian. Centennial Exhibition* (New York: Guggenheim Museum) 35–52.
160 Marty Bax. 2006. *Het Web der Schepping, Theosofie en Kunst in Nederland van Lauweriks tot Mondriaan* [The Web of Creation, Theosopy and Art in The Netherlands from Lauweriks to Mondrian] (Nijmegen: Sun Uitgeverij).
161 See for instance: Hans Janssen. 2017. "Inleiding [Preface]" in Jacqueline van Paaschen, *Mondriaan and Steiner: Wegen naar Nieuw Beelding* [Mondrian and Steiner: Paths to Neo-Plasticism] (The Hague: Komma, d'Jonge Hond) 7–8; Louis Veen (ed.). 2017. *Piet Mondrian: The Complete Writings, Essays and Notes in Original Versions* (Leiden: Primavera Press) 29.
162 Rosalind Krauss. 1979. "Grids," *October* 9: 52.
163 Idem, 61–64.

lies—like a trauma that must be repressed—a symbolist window parading in the guise of a treatise on optics."[164]

While Mondrian never spoke of his abstraction as an instrument of repression (he rather spoke of it in terms of destruction and re-construction), it is fair to say that his grids embody an alternative to symbolist visual languages for the expression of the spiritual. His abstraction embodies an artistic inner vision, which he characterizes as wholly other than visual vision: "this other perception is an inner transformation that one cannot explain by physical abnormality, as some doctors would do. (Some psychiatrists therefore blame it on mental aberration!)."[165] I argue elsewhere that this spiritual mode of vision is what Mondrian had wanted to embody in his paintings, and through these paintings elicit in his viewers,[166] but his contemporaries were not necessarily convinced. In the quotation above, Mondrian is referring to an article published by the psychiatrist and utopian Frederik van Eeden, who had argued that Mondrian's colorful Luminist paintings exhibited in the Stedelijk Museum in 1909 were the products of mental illness.[167] Van Eeden's article was the first in a long line of scholarly interest in the psychological state of Mondrian, investigated as one of the causes for the painter's interest in abstraction and radical pursuit of the bare painterly essentials.[168]

Rather than taking a psychoanalytical approach himself, Michael White investigated the impact of the emergence and popularization of psychoanalysis on the development of the art of Mondrian. He explores how the development of abstract art runs parallel with the development of a psychoanalytical

164 Idem, 59.
165 Piet Mondrian. 1918. "De Nieuwe Beelding in the Schilderkunst [Neo-Plasticism in the Art of Painting]," *De Stijl* 1.7: 76. In Dutch, the original quotation reads, 'Innerlijk ziet de schilder anders dan hij visueel ziet: zijn ander zien is een innerlijke werking en moet toegeschreven worden aan physieke afivijkingen (vandaar zeggen sommige psychiaters dat het een geestelijke afwijking is!) zooals sommige doctoren doen.'
166 Lieke Wijnia. 2018. "Knowing through Seeing: Piet Mondrian's Visions of the Sacred," Company of Ideas Forum, Jeffrey Rubinoff Sculpture Park, 26 June.; Lieke Wijnia. Forthcoming. "Piet Mondrian's Abstraction as a Way of Seeing the Sacred" in Louise Child and Aaron Rosen (eds.). *Religion and Sight* (Sheffield: Equinox Publishing).
167 Frederik van Eeden. 1909. "Gezondheid en Verval in Kunst [Health and Decay in Art]," *Op de Hoogte: Maandschrift voor de Huiskamer* 6.2: 79–85.
168 Peter Gay. 1976. *Art and Act. On Causes in History? Manet, Gropius, Mondrian* (New York, London: Harper and Row); Joose Baneke (ed.). 1993. *Dutch Art and Character: Psychoanalytic perspectives on Bosch, Breugel, Rembrandt, Van Gogh, Mondrian, Willink, Queen Wilhelmina* (Amsterdam: Taylor & Francis); Donald Kuspit. 1994. "Art: Sublimated Expression or Transitional Experience: The Examples of Van Gogh and Mondrian," *Art Criticism* 9.2: 64–80.

theory of art, in which the unconscious and abstraction are strongly linked.[169] White demonstrates how the concept of 'inner vision' as used by Mondrian in his writings was in fact informed by psychoanalysis. The publication and popularization of Sigmund Freud's texts in The Netherlands impacted the diagnosis not only of individuals, but even so of modern culture in its entirety. With his radical abstraction, Mondrian was often presented as exemplary of the demise of this modern culture.[170]

Furthermore, Mondrian's Calvinist upbringing is subject of academic interest. Suzanne Deicher explores the role of Protestantism in Mondrian's art and writing.[171] She has highlighted two notions in particular, stemming from his reformed protestant upbringing. First, she argues for the importance of the conception of the church as pure embodiment of the truth within a context of chaos—Mondrian believed his art to function in such a manner. Second, Deicher makes a case for the role of the martyr as suffering instrument of grace—which impacted Mondrian's ideas about the implications of his own artistry. He dealt with the suffering resulting from misunderstanding by his contemporaries for an ultimately higher good, which only more spiritually developed people in the future would be able to understand.[172] In his 2017 Watson Gordon Lecture, Joseph Masheck also took a deliberate distance from the popular Theosophical recourse. He reinterpreted not only the spiritual in Mondrian's classic abstract works from 1920s and 1930s, but also his public and critical reception until the present day from a Neo-Calvinist perspective.[173]

Finally, while Mondrian's sources of spiritual inspiration were varied, so were his other interests. He was famously invested in jazz music, fascinated by the seemingly never-ending energy radiating from life in urban centers like Paris, London, and New York, and endearingly excited about Disney-films when they first appeared in cinemas. These interests do not exist separately from Mondrian's spiritual convictions. Rather, they developed in tango, and as such, are all crucial in creating an overall understanding of his art.

The example of Mondrian demonstrates how he translated a variety of spiritual affinities, and found a variety of modes of translation, into his work—both

169 Michael White. 2006. "Dreaming in the Abstract: Mondrian, Psychoanalysis and Abstract Art in the Netherlands," *Burlington Magazine* 148.1235: 98–106.
170 Idem, 100.
171 Susanne Deicher. 1995. *Piet Mondrian, Protestantismus und Modernität* (Berlin: Reimer Verlag).
172 Susanne Deicher. 1994. "Zuivere Vorm en een Verhaal van Lijden [Pure Form and a Story of Suffering]," *Jong Holland* 4: 6–17.
173 Joseph Masheck. 2018. *Classic Mondrian in Neo-Calvinist View*. The Watson Gordon Lecture 2017 (Edinburgh: National Galleries of Scotland and The University of Edinburgh).

his painting and his writing. While many scholars attempt to claim primacy for one of the spiritual or religious traditions in terms of impact on his route to abstraction, and his resulting art, to date a coherent, integrated approach to the spiritual embedding of his artistic interests, inspirations, and intentions is yet to be produced. The multi-dimensional example of Mondrian is reflective of what Molendijk called 'intertwinements' and what Bender has called 'entanglements'—the plural configurations that make up individual actions within a wider societal context.

Mondrian's varied spiritual interests and modes of translation into art continue to be a source of interest and debate for scholars. These interests are often analyzed in terms of individual specificity. Yet, they are also of relevance in terms of a broader cultural interest. In his 1975 book *Modern Painting and the Northern Romantic Tradition*, Robert Rosenblum attempted to present an alternative narrative to modern art history, in which he placed Mondrian in the context of a broader cultural development. Rosenblum's alternative modern art historical reading carried the potential to counter the above-described paradox of the joint acknowledgement of spirituality and difficulty in dealing with it.

Instead of following the traditional development of modern art with nineteenth- and twentieth-century Paris at its heart, Rosenblum proposed an alternative reading,

> based not on formal values alone—if such things can really exist in a vacuum—but rather on the impact of certain problems of modern cultural history, and most particularly the religious dilemmas posed in the Romantic movement, upon the combination of subject, feeling, and structure shared by a long tradition of artists working mainly in Northern Europe and the United States.[174]

In addition to the translations of Christian iconography into political portraits, as discussed in the previous chapter, artists in the protestant north also translated the sacred to the secular in another realm: "one in which we feel that the powers of the deity have somehow left the flesh-and-blood dramas of Christian art and have penetrated, instead, the domain of landscape."[175]

Romanticism developed in response to the rationalism of the Enlightenment period, expressing a longing for a pre-modern and un-rationalized past. Characterizing it as a 'modern movement of (re)enchantment,' Richard

174 Rosenblum, *Modern Painting*, 7–8.
175 Idem, 17.

Jenkins attributes a continued relevance to Romanticism throughout the modern world,[176] especially in contemporary perceptions of nature, and, indeed, art. By means of the notion of the sublime, the spiritual was not only found in new places, but it was also described in new terms. Through the notion of the 'sublime,' Romanticism offered an alternative vocabulary for institutional religious terminology to describe an experiential dimension of the sacred, holy, or numinous—which was to be experienced through encounters with nature or art.

Originally rooted in a longing for the past, the notion of the sublime received a twentieth-century dimension in a manifest written by painter Barnett Newman in 1948. He famously stated in "The Sublime is Now" how American artists were going to be at the forefront of the development of modern art, with an abstraction that existed independently of history—something Mondrian had also been striving for.

> We are freeing ourselves of the impediments of memory, association, nostalgia, legend, myth, or what have you, that have been the devices of Western European painting. Instead of making *cathedrals* out of Christ, man, or 'life,' we are making it out of ourselves, out of our own feelings. The image we produce is the self-evident one of revelation, real and concrete, that can be understood by anyone who will look at it without the nostalgic glasses of history.[177]

For Rosenblum, there is a connection between the Romantics and Newman's translation of his 'own feelings' and 'revelation' into abstraction. "During the Romantic era, the sublimities of nature gave proof of the divine; today, such supernatural experiences are conveyed through the abstract medium of paint alone. What used to be pantheism has now become a kind of 'paint-theism.'"[178] Rosenblum's focus on Northern artistic traditions and its roots in Romanticism provided an almost logical place for the spiritual in artistic developments throughout the nineteenth and twentieth centuries, from sublime landscapes to radical abstraction.

In Rosenblum's rewriting of the art historical canon, the spiritual in its pluriform constellations featured as a self-evident characteristic of modern art.

176 Jenkins, *Disenchantment, Enchantment and Re-Enchantment*, 19
177 Barnett Newman. 1948. "The Sublime is Now" in Charles Harrison and Paul Wood (eds.). 2003 (1992). *Art & Theory 1900–2000. An Anthology of Changing Ideas* (Malden: Blackwell Publishing) 582.
178 Robert Rosenblum. 1961. "The Abstract Sublime," *ARTnews* 59.10: 41.

This canon-rewriting also results in the reassessment of the roles of individual artists. Whereas the history of the spiritual in modern art often begins with Wassily Kandinsky's 1912 book *On the Spiritual in Art*, his place of primacy is simultaneously continuously disputed. After several exhibitions in her native Sweden, a recent exhibition in the Guggenheim Museum in New York provided Hilma af Klint with a global reputation of 'the first' abstract artist in Europe.[179] While the 1986–87 *The Spiritual in Art* exhibition already featured her work and an essay in the exhibition catalogue about how she translated her own spiritual activities into art,[180] the 2018–19 exhibition *Hilma af Klint: Paintings for the Future* in one of the temples of modern art significantly impacted the international reception of her work.[181]

Af Klint's artistic work was immersed in her spiritual practices, these two dimensions were enabling factors. The acknowledgement of this symbiosis is difficult to capture with an art historical mode of thinking exerted by the religion-secular binary. Departing from the conviction that artistic practices have a fundamentally secular nature simply does not suffice. It brings us back to Hans Belting's distinction between likeness and presence. Arguably, to fully grasp the art works of artists like Mondrian, Af Klint, and Newman, the paintings have to be regarded for their capacity for presence, as embodiments of the spiritual.

In European contexts this mode of thinking is rooted in Romanticism, yet, in other parts of the world abstraction has had a much longer spiritual foundation. Maroon culture in Suriname, sacred geometry in the Islamic world, calligraphy in China, and Aboriginal visual languages in Australia, Canada, and the United States all refuse to be understood from a binary distinction between religion and the secular. A postsecular approach can move the analytical framework beyond this binary analysis.

Paradoxically, when these art forms travel into art institutions and become part of the international art market, subject to marketing and collection, their fundamental spiritual nature is challenged. The art works become disenfranchised from their original spiritual investments, often being appreciated for

179 The exhibition *Hilma Af Klint, Paintings for the Future* ran between 12 October 2018–23 April 2019 at the Solomon R. Guggenheim Museum in New York.
180 Åke Fant. 1986. "The Case of the Artist Hilma af Klint" in Maurice Tuchman (ed.). *The Spiritual in Art: Abstract Painting 1890–1985* (New York: Abeville Press) 155–164.
181 Julia Wolkoff. 2018. "How the Swedish Mystic Hilma af Klint Invented Abstract Art," *Artsy*, 12 October. https://www.artsy.net/article/artsy-editorial-swedish-mystic-hilma-af-klint-invented-abstract-art; Nana Asfour. 2018. "The First Abstract Painter was a Woman," *Paris Review*, 12 October. https://www.theparisreview.org/blog/2018/10/12/the-first-abstract-painter-was-a-woman/.

their formal features more than their religious connotations. One of the largest challenges for institutions dealing with this work in their collections or exhibitions is how to maintain the works' spiritual qualities and honor these in the primarily secularized setting of the museum or gallery. This coincides with the presentation of art as an alternative to, or even secular form of, religion.

4.2 Art as Spiritual Alternative to Religion

In the summer of 2015 the BBC Culture website published an article by art critic and writer Jason Farago, with the telling title "Why Museums are the New Churches."[182] In the article, he explores how various elements of the museum function in parallel to religious institutions. Farago describes the 'new' religious nature of museums on the levels of buildings, objects, and engagement. His observations are rooted in a long tradition, as discussed in Chapter 2, which illuminates how museums are positioned and consumed in contemporary society. However, the created parallel does not only compare the two institutions, but even implies a replacement. From a postsecular perspective, three implications underlying Farago's observations require attention.

First, the most important premise of Farago's piece is that churches and museums are capable of serving identical purposes. The argument is based on the notion of individualized experience, as propagated by museums with displays consisting of white walls and singled out, individually placed art works. However, in addition to the individualized experience, it could be argued that religion has an important collective concern. Bringing people together and creating connections, churches offer the facilitation of social networks grouped around particular spiritual convictions. And, it remains to be seen to what extent the people who visit a contemporary art museum feel connected to their fellow visitors. While Farago's argument neatly fits topical scholarly concerns with individualized spirituality, the social concern of religion should not be ignored here. Even more so, especially in times of growing individuality, the longing for social embedding is pressing. With increasing efforts at community projects around, and involvement in the creation of, museum exhibitions, the ways in which museums facilitate collective efforts is an important topic of study.

Second, the use of the term 'new' in the article title and throughout the argument is bothersome. It implies there was an old, fixed status quo that is now replaced with a new, different situation. It implies the proverbial saying 'out with the old, in with the new.' Such observations, and consequential use of

[182] Jason Farago. 2015. "Why museums are the new churches," Website BBC Culture, 16 July. http://www.bbc.com/culture/story/20150716-why-museums-are-the-new-churches.

terminology, are rooted in secularization theories of modernity, the observation that religious traditions will lose ground in the western world. Therefore, this argument is rooted in the understanding that something else must inevitably fill the gap that institutional religion is leaving behind. For Farago, this gap is filled by museums. While there is an undeniable truth to the increasing public presence of museums, such a replacement thesis does not constitute a complete picture. Instead of the argument that religion and its institutions have disappeared, it would be more fruitful to think of these institutions as continuously transforming. As such, then, their interactions with cultural institutions such as museums and collaborative efforts with contemporary artists come to the forefront as well.

Third, rather than equating the two institutions of the church and the museum, religion can be regarded as part of a larger spectrum of practices, which people employ in their attempts to address existential questions—attempts at making sense of their life and the challenges offered by it. On this spectrum of sense-making strategies, museum practices—how museums are positioned through their collections, exhibitions, and activities, as well as how people use what museums have to offer—have an important place. Such a perspective allows seeing religious institutions and museums as co-existing instead of the one replacing the other. Rather than a comparative approach, or that of substitution, it allows for a relational view. Terry Eagleton analyzed the substance of this relation, in writing that art,

> has a good deal in common with religious belief, even in the most agnostic of environments. Both are symbolic forms; both distil some of the fundamental meanings of a community; both work by sign, ritual and sensuous evocation. Both aim to edify, inspire and console, as well as to confront a depth of human despair or depravity which they can nonetheless redeem by form or grace. Each requires a certain suspension of disbelief, and each links the most intense inwardness to the most unabashedly cosmic of questions.[183]

In the context of this essay, the question then becomes how religious institutions and museums relate, complement, and enhance one another through art.

A prevalent argument in response to replacement or substitution theses—which essentially lay the groundwork for the return narrative—is that artistic practices, and art in itself, *are* religion in its own right. As such, goes the

183 Terry Eagleton. 2001. "Having one's Kant and Eating It," *London Review of Books* 23.8: 9–10.

argument, art does not replace older religious traditions or practices, but it *is* religion of its own kind. Painter Gerhard Richter formulated this claim in 1964 as follows,

> Art is not a substitute religion: it is a religion (in the true sense of the word: 'binding back', 'binding' to the unknowable, transcending reason, transcendent being). But the church is no longer adequate as a means of affording experience of the transcendental, and of making religion real—and so art has been transformed from a means into the sole provider of religion: which means religion itself.[184]

The conviction of art being an independent form of religion, providing legitimacy for propagating art's spiritual elements, is also at the heart of Mike King's 2005 article "Art and the Postsecular."[185] King explores the work of Bill Viola and Anish Kapoor from a postsecular perspective, which he, at its most essential, defines as "a renewed openness to the spiritual."[186] The postsecular forms an answer to the 'hesitancy' with which scholars have circled around the notion of spirituality. He argues, "if we allow the joining of materiality / spirituality into a single whole again, then we can regain a lost language of interiority, one that allows us to speak without faltering on the work of such artists as Kapoor and Viola."[187] According to King, the strength of the postsecular is that it allows to move "beyond both secular reductionist assumptions and pre-secular renunciative assumptions."[188]

Highlighting the spiritual modalities of the esoteric, the shamanic, and the transcendent, he argues for a pluralistic perspective on the many other spiritual varieties that have informed artistic practice from the emergence of abstraction till this present day. Particularly, he proposes to reframe the category of the 'primitive' into the 'shamanic,' "an act that redeems our patronizing past within a present dialogue of equals."[189] Such a shift in vocabulary implies a shift in approach, with religion no longer presented parallel to art, but considered as an integrated aspect of art making across time and space.

184 Gerhard Richter. 2009. *Text. Writings, Interviews and Letters 1961–2007* (London: Thames & Hudson) 34.
185 Mike King. 2005. "Art and the Postsecular," *Journal of Visual Art Practice* 4.1: 3–17.
186 Idem, 6.
187 Idem, 3.
188 Idem.
189 Idem, 13.

Scholars in the field of literature also maintain an integrated approach to art and religion. In *Spiritual Identities: Literature and the Post-Secular Imagination*, the editors consider religion to be an ever-present feature in literary production, and artistic production in general. They argue, "the 'cracks' into which religious impulses flow in a world without religion are nothing other than the space of literature itself: literature is neither an alternative to, nor a substitute for religion, but a way in which religious experience can happen."[190] The postsecular framework gives way for scholars to use the term 'religion' (and its implications) to describe the ability of literature, visual art, and other forms of artistic production to establish a form of engagement with the transcendent.

Until now, such engagement has been studied through various routes, not in the least by scholars focusing on the notions of aesthetics and the senses. Often used in connection to one another, scholars want to draw attention to the immaterial implications of material objects, and vice versa. "Studying the aesthetics of religion translates into looking into the way religious actors perceive religious venues and practice with their senses, and examining how sensuous and cognitive perceptions are mutually engaged and how they constitute religious mind-sets."[191] Aesthetics are seen as a gateway to the sensuous dimensions of religious practices, and the role of objects and rituals in the context of these practices. To investigate the sensory implications of material and ritual actions, Birgit Meyer uses the term 'religious sensations,'[192] while Sally Promey calls it 'sensational religion.'[193] Both approaches consider religion as a site constituted by sensuous and cognitive engagements, in which rituals and material objects provide access to a supernatural deity or transcendent experience.

This brings us to one more essential element of the spiritual in art. Following from artistic conceptions and the making process is the public engagement with the resulting artwork. This, in turn, may just be one of the most important aspects of the postsecular framework in research on the arts.

190 Jo Carruthers, Andrew Tate (eds.). 2010. *Spiritual Identities: Literature and the Post-Secular Imagination* (Bern: Peter Lang) 5.
191 Inken Prohl. 2015. "Aesthetics" in S. Brent Plate (ed.). *Key Terms in Material Religion* (London: Bloomsbury Publishing) 10.
192 Birgit Meyer. 2008. "Religious Sensations: Why Media, Aesthetics and Power Matter in the Study of Contemporary Religion" in Hent de Vries (ed.). *Religion: Beyond a Concept* (New York: Fordham University Press) 704–723.
193 Sally Promey (ed.). 2014. *Sensational Religion: Sensory Cultures in Material Practice* (New Haven, London: Yale University Press).

4.3 Spiritual Engagement with Art

In a 2011 article in the *Journal for the Study of Spirituality*, Rina Arya described her attempts to pinpoint the place and form of spirituality in visual arts.[194] Identifying the spiritual as a feature of visual arts throughout time and place, she set out to discover what then exactly 'the spiritual' entails. In order to do so, she selected three works of art: an icon painting from c. 1260, an untitled color field composition from 1959 by Mark Rothko, and a video piece by Bill Viola from 1992. Three distinct works of art, rooted in different artistic and spiritual traditions. Notably each of the works were created in order to deal with devotional, transcendent, and existential questions.

Arya describes how, in order to capture the spiritual in these works, her methodology is of very personal nature. In addition to art theoretical and historical studies, her primary method of analysis is contemplation. She clarifies, "Contemplating the works enables me to understand, interpret, and engage with it. This happens on a number of different levels: deciphering the formal properties of the work and its accompanying content, and then engaging with the spiritual meaning."[195] These two aspects do not function independently. "In most cases understanding the former leads to an engagement with the latter—an understanding of the visual code deepens our awareness of the spiritual aspects of it."[196] By selecting three different types of art works, from various time periods, geographical locations, and media, Arya hopes to be able to say something about essential features of spirituality.

While a spiritual reading of the icon painting is seemingly legitimized by the fact that it is part of a larger religious tradition, Arya feels the need to justify in her own terms why the Rothko and Viola works showcase features of the spiritual. Overall, the spiritual is not inherently present in the works of art, it is not dependent on medium or the fact that a work of art is in a figurative or abstract style. Yet, as a result of her methodology, Arya discerns the spiritual in the responses the works of art evoke. As such, she identifies two conditions that are required for eliciting spiritual responses: 'receptivity' and 'context.'[197]

Receptivity indicates a type of openness to being fully in the present and opening oneself up to the artwork. "We place ourselves in the space of the artwork through the viewing and through the process of contemplation

[194] Rina Arya. 2011. "Contemplations of the Spiritual in Visual Art," *Journal for the Study of Spirituality* 1.1: 76–93.
[195] Idem, 78.
[196] Idem.
[197] Idem, 87.

become absorbed by the artwork."[198] Engaging with art becomes a multisensory experience, resulting in an immersive experience which does not only affect experiences of sight, but a range of other senses as well. The second requirement for the spiritual in art is the context of, as Arya characterizes it, 'appropriate' nature. Contemporary artworks situated in a museum call for meditation, while the same objects in other, non-set-apart contexts may evoke a more cognitive or rational response. "The context of the art gallery is less prescriptive"—in theory anything is possible in the museum, meanings are hardly ever fixed—and "the spiritual is activated in the encounter."[199]

An example of the importance of both receptivity and context, and how artists also pre-meditate on this, is the work of Mark Rothko. In particular, the display of paintings by Mark Rothko (1903–1970) in the so-called *Rothko Room*, installed in Tate Modern, London in 1970. The paintings were originally commissioned in 1958, for the Four Seasons restaurant on the ground floor of the Seagram Building in New York. However, Rothko decided his paintings needed a more suitable context and withdrew them from the project. During the sixties he donated the nine paintings to Tate Modern and had them installed in an especially dedicated room, where the viewer could engage with them in the intended contemplative manner. Until the present, Tate Modern has this room as a fixed part of their display and the room has proven hugely popular.[200] With the collaboration of the painter himself, the museum realized a space that allows for encounters of sublime, mystical, or sacred nature.

Of a different character is the Rothko Chapel in Houston, Texas. It is the only commission that Rothko ever received to have his paintings hung on the walls of a space built for religious purposes. In painting the works for this site, Rothko was indebted to a visit to the Byzantine church Santa Maria Assunte in Torcello, near Venice. He experienced a tension of despair and hope between seeing mosaics depicting The Last Judgment and a Madonna and Child placed across from one another in the space. This tension "between judgment and promise, between tragedy and hope" is exactly what he tried to evoke in the Houston Chapel.[201] Originally intended as a Catholic site, in 1971 the chapel was dedicated as a nondenominational space. In addition to the Byzantine church visit, another merging of religious customs and rituals is embodied in the space and its interior constellation. As Aaron Rosen observed,

198 Idem.
199 Idem, 89.
200 Rina Arya. 2016. "Reflections on the Spiritual in Rothko," *Religion and the Arts* 20: 315–316.
201 Annie Cohen-Solal. 2014 (2013). *Mark Rothko* (Amsterdam: Meulenhoff) 218.

By grouping his works in triptychs, Mark Rothko encouraged viewers to approach them as they would a traditional altarpiece. This was not, however, a repudiation of Judaism. Instead, working with the norms and expectations of a Christian space allowed Rothko the freedom to investigate religious dimensions he felt uncomfortable addressing directly in a Jewish idiom.[202]

The attributed spirituality of a broader, non-denominational nature to the works of Rothko continues to impact exhibition practices to this very day. In the 2014–15 exhibition in the Gemeentemuseum in The Hague,[203] the exhibition space was divided into two routes. One was of chronological nature, following Rothko's development from figurative depictions to his wholly abstract visual language. The other routing was titled 'emotional route,' via which the viewer immediately walked into the various rooms with the later color field paintings—known for their intended elicitation of a spiritual and transcendent experience. Rothko already cultivated this myth of spirituality himself, when he famously stated, "the fact that lots of people break down and cry when confronted with my pictures shows that I *communicate* those basic human emotions. The people who weep before my pictures are having the same religious experience I had when I painted them."[204]

This myth also translates into non-western contexts, with the prime example of the 2015 exhibition in the Seoul Arts Centre in South Korea.[205] The exhibition was staged in collaboration with the National Gallery of Art in Washington D.C. and featured fifty original works by Rothko. Inside the exhibition space, the Houston Chapel was recreated with paintings in a similar style to the ones in the actual chapel. Visitors were invited to enter the chapel and meditate. The emotional and spiritual elements of Rothko's work were particularly emphasized, which Hwasun Choe has analyzed as reflective of a broader cultural trend in Korea, a trend that actively encourages citizens to seek emotional healing. Within the exhibition, the art works of Rothko were regarded as instruments that foster emotional, and with that potentially spiritual, healing.[206]

That visual art is seen as an effective instrument for healing through reflection and for creating an attentive attitude that can evoke a mindful presence,

202 Aaron Rosen. 2015. *Art + Religion in the 21st Century* (London: Thames & Hudson) 12.
203 The exhibition was held between 20 September 2014–1 March 2015.
204 Selden Rodman. 1957. *Conversations with Artists* (New York: Devin-Adair) 93.
205 The exhibition was held between 23 March–28 June 2015.
206 Hwasun Choe. 2018. "Tears and Meditation in Exhibition: Healing or Cheating?," ISRLC Conference, Uppsala, 29 September.

is reinforced by Arden Reed's theory of 'slow art.'[207] Reed identifies two processes that have occurred since the eighteenth century, which are of importance to his understanding of slow art, and which coincide with the notions of (dis)enchantment; acceleration of daily life and secularization. As capitalist and technological inventions increasingly structured and heightened the pace of everyday life, the desire for quietness and opportunities for reflection grew. But, with secularization, the reflective moments were taken away from the structures of the work week.

"As a result, occasions to slow one's tempo became harder to access—like devotional practices requiring viewers to focus intensely on single works over long periods of time. Hence an increased need met decreased opportunities to address that need."[208] This leads Reed to conclude, *"Slow art came to supplement older sacred practices* by creating social spaces for getting off the train.... [A]s cultures sped up and sacred aesthetic practices waned, slow art came to satisfy our need for downtime by producing works that require sustained attention in order to experience them."[209] Slow art, then, can be any form of art that invites intense engagement from the viewer over an extended period of time, which can occur all at once or consist of repeated engagement throughout this longer period of time.

As with Arya's exploration of the spiritual in art, Reed's theory puts his own engagement, contemplation, and reflection center stage in the methodology. In fact, the reason Reed developed this theory is due to his experiences of repeated visits to Edouard Manet's *Young Lady in 1866* in the Metropolitan Museum of Art. Reed's is a theory of looking, of encounter, and of time— "Slow art stretches time out for its own sake, so that we experience its passing 'viscerally.'"[210] For which, again like Arya, the context is also of vital importance. Having had to embark on a journey—parallels to pilgrimage are easily made— before being able to encounter a work of art, results in a stronger investment and longer engagement with the work, than when an artwork is accidentally come across. Seeing an artwork in a museum or a natural surrounding can both be experienced as set-apart, but in a completely different manner. Where Arya located the spiritual as being activated through the encounter, Reed's argument is strongest in the parts where he pins down the historical conditions in which the desire for such activation emerged. Secularization, its impact on

207 Arden Reed. 2017. *Slow Art: The Experience of Looking, Sacred Images to James Turrell* (Berkeley, Los Angeles, London: University of California Press).
208 Idem, 11. Emphasis in original.
209 Idem.
210 Idem, 32.

the rhythm of daily life, and the consequences of perceived disenchantment play a large role in the construction of an argument for enduring engagement with art.

One particular type of slow art is long durational performance art, demanding attentiveness from the artist and the viewers—or sometimes participants—alike. A key feature in long durational art, and by extension potentially also in slow art, is asceticism. Throughout history, many artists have been known to work in secluded circumstances, away from the routine of everyday life, opening themselves up to inspiration for, and focus on, their creative practices.

In 1998, Charles A. Riley observed how, "a broad-based asceticism is a powerful factor in the intellectual life of our times[.] ... For many established and emerging artists, composers, choreographers, architects, writers, and philosophers, the lure of the ascetic ideal turns out to be one of the most vital (and misunderstood) creative forces in contemporary art."[211] Although Riley focuses mostly on how the life or work style of artists consisted of varying degrees of asceticism. Yet, as the research of Arya and Reed tries to indicate, the value of looking at artistic practices from the perspective of contemplation, attentiveness, and even asceticism, also rests in its implications for the audience. When it comes to long durational performance art, ascetic behavior is usually channeled by an artist, displayed for viewers, who in turn gain a fundamental role in completing and performing the work. The asceticism is extended from the artist onto the audience, offering a role of spiritual potential for all those involved.

A key example of contemporary performance art is the work of Marina Abramoviç. Trained as a painter at the Academy of Fine Arts in Belgrade, Abramoviç began to create performance pieces from the early 1970s onwards. Her mental and physical limits of endurance are at the heart of her pieces. By testing and stretching her own limits, she confronts the audience members with testing and stretching theirs. From the beginning, her performances contained elements of violence, pain, and danger. The ability to endure was a crucial feature in her upbringing, as her parents maintained an environment of strict rules. Abramoviç has loving memories of her deeply religious grandmother, who had a particular affection for ritual.[212]

211 Charles A. Riley II. 1998. *The Saints of Modern Art, The Ascetic Ideal in Contemporary Painting, Sculpture, Architecture, Music, Dance, Literature, and Philosophy* (Hanover NH: University Press of New England) 2.
212 Marina Abramovic, James Kaplan. 2016. *Walk through Walls, A Memoir* (London: Fig Tree/Penguin) 6.

Additionally, Abramoviç has a number of notable spiritual affinities, maintaining interests in shamanism, Tibetan Buddhism, Vipassana, mindfulness, and other forms of alternative and new age spirituality. She believes in synchronicity, in parallel worlds, and in karma.[213] This combination of autobiographical experiences and attitudes—strict rules, ritual, spirituality—is the foundation of her ascetic behavior and results in the performances in both tests of endurance and a spiritual appeal, for artist and audience alike.

Abramoviç gained global fame with the 2010 performance *The Artist is Present* in the Museum of Modern Art in New York. During this performance, Abramoviç was literally present during the opening hours of the museum, between March 14 and May 31. As she described it, "The rules were simple: Each person could sit across from me for as short or as long a time as he or she wished. We would maintain eye contact. The public was not to touch me or speak to me."[214] Beforehand both the museum and the artist were slightly worried that no one would show up. In the end, close to 1400 people occupied the chair located across the artist.[215]

In addition to the many celebrities who sat with Abramoviç, people started lining up during the nights, sleeping on the pavements, and a number of visitors often returned. One of the most notable visitors was Paco Blancas, who eventually managed to sit with Abramoviç twenty-one times. Afterwards, he had the number twenty-one tattooed on his forearm. When asked about the reasons of his frequent returns, he not only recounted his individual experiences, but he also an experienced sense of community. "I love meeting people in line. [...] I keep in touch with them and we e-mail constantly to talk about our experiences. It's like a little community of people who come to participate in the piece."[216] Following the performance, Blancas made a book titled *75*, recording the experiences of seventy-five people, who were asked to record their experiences of sitting across from Abramoviç in seventy-five words. The resulting book was presented to the artist, as a tribute to her performance.[217] Abramoviç stated afterwards that *The Artist is Present* made her aware of how there is a need and desire amongst art audiences to truly become part of the performance, rather than being reduced to the role of mere spectators. It led

213 Sandra Smallenburg. 2017. "Marina Abramoviç, Het interview," *Het Blad bij NRC* 9: 17.
214 Abramoviç, Kaplan, *Walk through Walls*, 309.
215 Holland Cotter. 2010. "700 hour Silent Opera Reaches Finale at MoMA," *New York Times*, 30 May. http://www.nytimes.com/2010/05/31/arts/design/31diva.html.
216 Julia Kaginsky. 2010. "Visitor Viewpoint: MoMA's Mystery Man," Website Museum of Modern Art, 10 May. http://www.moma.org/explore/inside_out/2010/05/10/visitor-viewpoint-momas-mystery-man.
217 Abramoviç, Kaplan, *Walk through Walls*, 316–317.

her to conclude, "The community that had vanished from performance art had returned, only much bigger and far more inclusive than ever before."[218]

While the performance impacted several participants' lives, it also made Abramoviç herself wonder about the nature of her art.

> I'd always thought of art as something that was expressed through certain tools: painting, sculpture, photography, writing, film, music, architecture. And, yes, performance. But this performance went beyond performance. This was life. Could art, should art, be isolated from life? I began to feel more and more strongly that art must *be* life—it must belong to everybody. I felt, more powerfully than ever, that what I had created had a purpose.[219]

It is the same rhetoric as artists and scholars who, as described above, identify art as religion. Meanwhile, Abramoviç extends it to the realm of life entirely. Which, arguably has similar implications as the categorization of art as religion, because of the focus on existential themes and transcendent experiences. Here the focus is not only on individualized spiritual experiences, but, perhaps even more so, on the importance of a sense of community experienced for the duration of the performance.

For the contemporary art museum to have any form of spiritual significance it needs to be experienced as a space of transformation and community for all those involved—curators, visitors, and artists alike. Paralleling artists and priests, Nicholas Buxton observed, "As with participation in religion, so experiencing art may bring about transformation, if not salvation, in the one who experiences it. Indeed, at least one of the purposes of art is to change the way we look at things, the world or each other."[220] Not only can the sacred be incorporated in the artworks as produced by artists, the encounter of audience members are of equal importance in completing the artwork as such, and in providing it with meaning.

Museums, sites of sacralizing nature, offer spaces in which meaningful encounters can occur. This is something not always readily accepted by museum professionals, but often desired by visitors. Equal to art works in their own right, the set-apart museum context intrinsically possesses the potential to offer encounters with the non-ordinary. Afterwards these time- and place-bound encounters are consequentially transferred into the realm of ordinary,

218 Idem, 317.
219 Idem, 319. Emphasis in the original.
220 Buxton, *Creating the Sacred*, 55–56.

everyday life. As Arya described the religious sensations that an encounter with a painting by Rothko can elicit: "It is an experience that can only be felt at the time and rationalized later."[221] The memory of the encounters, the intellectual stimulation they evoked, or embodied and emotional experiences they resulted in, function as hints of the non-ordinary in ordinary, everyday life.

From a postsecular perspective, the process of spiritualization has a multifaceted character in the understanding of the dynamics between artistic practices, art institutions, and art audiences. The acknowledgement of spirituality in artistic practices has come a long way over the past decades, but the formulation of an integrated approach to how the spiritual navigates between religion and the secular is still waiting to happen. Rather, art is often positioned as modern spiritual alternative, substitute or replacement of institutionalized forms of religion. Yet, from a postsecular perspective, scholars and artists have argued that art functions *as* religion, in which the secular and the spiritual have a lasting presence. Finally, new modes of spiritual engagement with art are also argued for in scholarship as well as pursued in artistic practices. Both on individualized and collective levels, such projects seem to adhere to a twenty-first century mindset, which is dictated by acceleration and secularization, eventually resulting in a quest for spiritualization.

5 Concluding Perspectives

With this essay, I have aimed to explore the potential and relevance of the notion of the postsecular in studying the presence of religion in modern and contemporary art. I have argued how three processes are of importance in employing the framework of the postsecular: secularization, diversification, and spiritualization.

Whereas theories of secularization are predominantly tied up with one overall process—that of modernization—the postsecular requires a theoretical framework that reinforces its multifaceted character. As such, the postsecular has the ability to reach beyond much-posited observations that religion has 're-emerged' or 'returned.' Religion may have regained attention in academic scholarship, yet it has never been away from the arts. For me, that is the departure point of the postsecular.

In this final part, I will offer some concluding observations, which serve as an invitation to participate in future roads of enquiry into the postsecular and the arts. But first, I would like to take you on a journey along several

221 Arya, *Reflections on the Spiritual in Rothko*, 323.

art exhibitions in The Netherlands—to illustrate how the exploration of site-specific cases is crucial in transforming the postsecular from a theoretical endeavor into an empirical one.

5.1 One Dutch Fall

At the time of writing this essay throughout the fall of 2018, Dutch art museums have been bustling with religion. In my self-identifying secular home country, some of these museums engage very openly with art from religious traditions or spiritual movements, while others incorporate religion, spirituality, and transcendence in more implicit manners in their exhibitions and communication outlets. One thing seems to be certain: religion is by no means the prerogative of specialized institutions like the Icon Museum in Kampen, the Biblical Museum in Amsterdam, the Museum Catharijneconvent in Utrecht, or the Museum for Religious Art in Uden. A small survey illustrates the depth and variety in which the notions of religion and spirituality inhabit Dutch art museums.

In the northern city of Groningen, the contemporary art museum hosts *Good News for Modern Man*, the first Dutch retrospective exhibition of American photographer David LaChapelle (b. 1963). His smooth, highly stylized, and controversial photographs are abundant with religious iconography that he resituates in consumerist and capitalist utopias, such as shopping malls, brightly lit diners and kitchens, and made-up, sugar-sweet natural paradises. Everything is over the top, fake, and human-made. The various photographic series on display combine urban street culture, sexualized popular imagery, and religious iconography. For example, the 2003 series *Jesus is my Homeboy* features a *Last Supper*, in which Christ is surrounded by tough-looking gang members in a non-descript room where fly-catchers are hanging from the ceiling. There is also an *Anointing* scene, in which Christ sits in a dirty kitchen, while a scarcely clothed blonde reminiscent of a Mary Magdalene figure is anointing his feet with cocoa butter body oil. And *Intervention*, a scene in which Christ is meddling between what appears to be a desperate prostitute and two police agents ready to secure her in handcuffs in a deserted New York City street. The exhibition opens with one of LaChapelle's best known works, *American Jesus: Hold me, Carry me Boldly* (2009), in which a Christ figure holds the body of popstar Michael Jackson, echoing how Mary holds the body of Christ in a traditional Pieta scene. They sit in a natural backdrop, brightly lit by spotlights hanging in the trees, while Jackson's iconic white glove is lying on one of tree trunks. One way of reading LaChapelle's photographs is to see them as challenges of what is regarded holy in contemporary Western culture, dominated by mass

media, neo-liberalism, and capitalism, in which artificiality and sacrality are more closely related than we might like to think.

At the same time, in the very south of the Netherlands, the Maastricht Bonnefanten Museum displays the results of an artistic research project by Dutch painter Helen Verhoeven (b. 1974). She was invited to study the classical and religious themes in the museum's medieval art collection. Verhoeven selected nine works from this collection and through the production of new paintings she reinterpreted iconic themes like the Fall of Eden, the Life of Christ, biblical adultery, mythological rapes, and undesired pregnancies. With a proclaimed secular eye, Verhoeven translated the predominantly religious themes into a contemporary vocabulary. This translation process has the aim of asserting and reinforcing the enduring relevance of biblical tales, by subscribing to the human characteristics they consist of. And vice versa, she translated the violence and human excesses of today's world into the historically rooted visual and thematic vocabulary of Christianity. The large canvasses, which she collectively titled *Oh God*, are mutually overwhelming by their large scales and disturbing thematic nature.

In between these two geographical outliers in the Netherlands, the Rijksmuseum Twenthe in Enschede showed a temporary exhibition titled *Joy and Sorrow, Dutch Families in Prosperity and Adversity*. The assembled family portraits from the seventeenth and eighteenth centuries often showed more family members than those actually alive at the time of painting. Deceased family members would be depicted as if still alive and newborn infants could be added at a later stage. Stillborn or early deceased children were usually depicted as angels in the sky. As such, these paintings are by no means a realistic representation of a certain moment in time, but demonstrate strategies of adaptation and transformation as expressed in contemporary times through photoshop or snapchat filters. But there is more to these objects than this curiosity factor. Primarily, the paintings functioned as enduring commemorative objects for those who commissioned them, reflecting the changing configuration of a family over time and demonstrating how the bereaved shaped their sense of loss of next of kin through material artistic means, and provided it as such a place in their everyday environment.

While these three museums each had one exhibition with religious subject matter, one museum beats them all. At the time of writing this essay, the Gemeentemuseum in The Hague[222] hosted four exhibitions in which religion

[222] In the Fall of 2019, the Gemeentemuseum Den Haag changes its name to Kunstmuseum Den Haag.

was a major theme, and was a primary lender to a spiritually-themed exhibition elsewhere.[223] The Gemeentemuseum was built in the 1930s, according to the designs of one of the country's most important architects Hendrik Berlage. He intended the museum as a true temple of modern art, which one enters through a pergola that separates the busy street and the actual entrance to the museum.

This way of entering the building was meant to physically and mentally distance the visitors from the world of the everyday, mundane routine, which, in turn, was seen as a prerequisite to fully engage with the displayed arts inside of the museum. This engagement had to happen in a very unstructured manner. The internal design of the large museum building is of such nature that hardly any exhibition room has the same shape and size as the one next to it. Visitors would embark on a true voyage of discovery, with an open mindset of whatever would cross their way, and prepared to be overwhelmed at any moment throughout the visit. This could not occur by simply following a numbered, symmetrical plan, but rather through losing one's way in the overwhelming amount visual and applied arts presented inside.[224]

The only sense of direction is symbolically provided by a female figure depicted in a large relief by sculptor Willem van Konijnenburg (1868–1943). This relief is prominently positioned in the entrance hall of the museum. The female figure symbolizes the city virgin of The Hague, who guides the people of the city, depicted in the lower half of the work, to the different artistic disciplines in the museum (applied arts, musical instruments, prints, history, modern art) represented by five angels surrounding the city virgin. The relief is inscribed at the bottom with the lines, *Eer 't God'lijk licht in d'openbaringen van de kunst* (which translates as "Honor the divine light in the revelations of the arts"). The relief reinforces the ideals upheld by Berlage that the arts resulted from divine inspiration and that they simultaneously have the power to educate people.

More than a hundred years later, in the fall of 2018, the duality of ideals concerning inspiration and education is of no less prevalence in the museum world than in the first half of the twentieth century. The smallest of the

223 These exhibitions were: *At Sea, Jan Toorop, Piet Mondrian, Jacoba van Heemskerck, Ferdinand Hart Nibbrig* (July 14–November 18, 2018); *Splendor and Bliss, Arts of the Islamic World* (September 8, 2018–March 3, 2019); *Alexej von Jawlensky, Expressionism and Devotion* (September 29, 2018–January 27, 2019); *Marc Mulders, Flowers and Animals*, September 29, 2018–January 27, 2019).

224 Having worked on several research projects in the Gemeentemuseum, I know from experience when walking through the exhibition spaces with a visible employee's badge, the most frequently asked questions concern directions. The majority of contemporary visitors seem to feel more frustrated than spiritually enlightened from the lack of orientation.

four religion-themed exhibitions during the fall of 2018, is one dedicated to the work of painter Marc Mulders (b. 1958). Throughout his career, Mulders has made art that taps into his Catholic upbringing and his continued involvement with this religious tradition, despite his official departure from the institution. His work is generally inspired by faith, even in the case of the exhibition *Flowers and Animals*. It focuses on the situatedness of Mulder's studio in the countryside. He calls his studio and the surrounding gardens 'My own private Giverny,' a direct reference to the gardens of Impressionist Claude Monet. Not only flowers themselves inspire Mulders, but also the light and air surrounding them. These natural elements are sources of life, which the artist wants to capture. While the religiosity here is not directly recognizable as representative of an institution or tradition, on the museum website the director expresses his admiration of Mulders' religious belief, as a person of faith, in the healing power of art.

The subtitle of the exhibition with work of Russian Expressionist Alexej von Jawlensky (1864–1941) directly indicates its focus on spirituality: *Expressionism and Devotion*. A contemporary and colleague to Wassily Kandinsky and Gabriele Münter, Von Jawlensky shared the interest in artistic expression as pure emotion and perception. Framed as a predecessor to widespread contemporary spiritual movements like new age and mindfulness, Von Jawlensky's interest in esotericism is highlighted through his series of *Savior's Faces* and *Mystical Heads*. Large eyes in various degrees of abstraction prime their looks onto the viewer, inviting them into a reflective, or even spiritual, mode themselves. Von Jawlensky repeated the same motif over and over, in different variations. The meditative quality of repetition was an important spiritual source for him, calling his mode of art production 'prayer and meditation in color.'

Of a different caliber is the Gemeentemuseum exhibition *Splendor and Bliss, Arts of the Islamic World*. Drawing from the museum's collection of Islamic applied arts, this exhibition turned into a multi-faceted outreach project. On the one hand it informs and educates the museum visitor about Islamic religious, historical, and cultural objects, while on the other hand it aims to introduce and include in the museum activities for the many inhabitants of The Hague, if not The Netherlands, with Islamic roots. Representation and participation are the keywords in this project, in which religious symbolism and functions of the objects are presented as manifestations of faith and as representative of general cultural phenomena.

The fourth in-house, religion-themed exhibition had a mundane source of origin. In 2018, The Hague commemorated the 200-year anniversary of the initiation of the first bathhouse at Scheveningen beach. The Gemeentemuseum was part of a citywide cultural program, with three sea-themed exhibitions.

One of these was *At Sea: Jan Toorop, Piet Mondrian, Jacoba van Heemskerck, Ferdinand Hart Nibbrig,* displaying works of four artists who found inspiration at the seaside in the southern Dutch province of Zeeland. While they were at different stages of their careers when they met in Zeeland between the years of 1908–1915, the painters shared the seaside as their source of inspiration. Strongly related to the relatively new esoteric movement of Theosophy and spiritual practices as meditation, these painters worked for a couple years in a brightly colored painting style, called Luminism. The exhibition framed the spiritual mindset of the various artists through their search for mystical characteristics of the seaside and its inhabitants, being surrounded by natural forces.

One of these artists was the focal point of the final, external exhibition that the Gemeentemuseum is involved in. Museum director Benno Tempel was invited to guest-curate the exhibition *The Spiritual Path of Mondrian,* in the Villa Mondriaan Museum in the eastern town of Winterswijk. Drawing from the collection of the Gemeentemuseum, this exhibition explored the early years of Mondrian's painting career. Growing up in a Calvinist family, Mondrian became increasingly interested in esotericism in general, and Theosophy in particular, when he began his studies in Amsterdam (while at the same time he registered with the reformed church once he arrived in Amsterdam). The transition from membership of an institutional religion to an orientation into a relatively new spiritual movement is the main storyline within the exhibition, ending around the year 1912 when Mondrian moved from Amsterdam to Paris.

Without it being an explicitly formulated aim in the Gemeentemuseum's mission statement, it can be safely stated that the constellation of exhibitions and activities demonstrates how in this art museum, religion and spirituality were topics of particular dominance and relevance in the display of their collections during the fall of 2018. To make sense of what was going on here, an art historical approach will not suffice. Instead, a reorganized analytical toolbox is required. In this essay I have set out to explore in which ways—by focusing on the processes of secularization, diversification, and spiritualization—the postsecular has the potential to contribute to such reorganization. Four concluding observations about the nature of the postsecular are in order.

5.2 *The Postsecular Is Work in Progress*

As will have become clear from this work, the theoretical framework of the postsecular in relation to the arts is a project in the making. In the first chapter I cited Lori Branch, who introduced her symposium presentation by saying her paper was of a rather personal nature, because it was an active contribution to the shaping of the postsecular. This work needs to be regarded such a

contribution as well. Unlike other contributions to the Brill *Research Perspective* series, this essay does not provide an extensive historical overview of literature and academic developments. Due to its recent emergence, this is not possible for the postsecular, and in particular not for the postsecular in relation to the arts. In disciplines like political theory and sociology, the postsecular has seemingly reached a reflexive stage.[225] And while artistic practices are often provided as an example of legitimation of the postsecular in these disciplines, the place of the postsecular in the academic study of the arts is still in its formative phase. For one, we need to figure out how to use the terms in relation to one another, the postsecular and the arts. Is there such a thing as postsecular art? Should we speak of the postsecular as a characteristic in art? Is the postsecular a societal or intellectual condition to which art responds? I think all three options are viable; especially now that the term of the postsecular is increasingly used in public debates. This allows artists to actively integrate it in their practices. Yet, from an academic perspective I would argue it is useful to—for now—think about the postsecular as a framework from which artistic practices can be studied, especially in terms of how religion, the secular, and/or the spiritual intertwine in these practices. In such a framework, there is room for multiple disciplinary perspectives (art history, theology, the study of religion), which can inform each other. After all, the postsecular is a tool to think through the implications of artworks, from the perspective of the artist, institutional context, and reception alike. As such, the time seems to have come to leave the conceptual high ground and get our feet in the mud. The postsecular, when it comes to the arts, is in dire need of empirical grounding.

5.3 *The Postsecular Exists through Negotiations*

Through the many case studies in this essay, I have tried to demonstrate how the postsecular benefits from not being considered as an abstract, impersonal process, but rather as a product of ongoing negotiations. Such negotiations take place in the field between a variety of contributors: artists, curators, audiences, critics, educators, journalists, etc. This is the reason why the types of sources I have cited throughout this work are not exclusively academic, but come from a variety of authors. Together, these actors negotiate the multifacetted configurations of the postsecular, the intertwinements of religion and the secular into new constellations. Despite the earlier presented complexities of the notion of translation, the variously identified translation strategies are key

[225] Beaumont, Justin et al. (2018). "Reflexive Secularization? Concepts, Processes and Antagonisms of Postsecularity," *European Journal of Social Theory* XX(X): 1–19. DOI: 10.1177/1368431018813769.

in these negotiations. In the negotiations about, and performance of, strategies of translation, meanings are shifted, become fluid, and are reinterpreted. In a continuously transforming and globalizing world, translation has a multidimensional presence in many parts in the public domain—media, politics, education, the arts. Translation may result in misunderstanding or contestation, but through negotiations it can also result in new meaningful configurations. Translation is required when artistic intentions and artistic interpretations are placed in conjunction. Notions of the secular, religious, or spiritual invested by the artist ideally directly translate to audiences throughout time and place. However, time- and site-specific modes of translation are usually required to make an artwork resonate for new audiences. While artistic intentions turned into visual and material means may eventually differ vastly from later interpretations of these visual and material means, both modes of translation are valuable from the perspective of the postsecular.

5.4 The Postsecular Is a Public Affair

The postsecular acknowledges the simultaneous prevalence of secularization and the transformed and/or diversified presence of religion in the public sphere. While the notion offers a critical distance to the long dominance of secularization theories of modernity, the secular state of democratic societies is not compromised. Rather, the postsecular draws attentions to the continuous negotiations for co-existence of religion and the secular in the public sphere. Therefore, this essay has stressed the importance of public institutional contexts—in this case museums, exhibitions, and galleries. These institutional sites mediate between the public domain at large and individual artists, not by merely showcasing art, but also through their curation as they actively contribute to the public sphere. Art museums both represent and shape public discourse on the historical and contemporary place of religion in society. As museums increasingly become aware of their public responsibility, they strive towards more inclusivity and representation in their activities. In positioning themselves in a public domain that is characterized as postsecular, religion has become a topic that can no longer be ignored. It faces museums with the challenge of continuous negotiations about religion and the spiritual in its perceived secular space. In order to achieve an interdisciplinary framework for the postsecular and the arts, art's public institutions seem an effective point of departure for empirical research on these negotiations of the postsecular.

5.5 The Postsecular Defies the Religion-Secular Binary

The postsecular emerged as a theoretical notion in response to secularization theories that strictly defined and boxed religion. While some scholars have

expressed their concerns about how the postsecular continues to reinforce strict categorizations of religion and the secular, this essay's exploration has tried to convey that the framework of the postsecular has the potential to do quite the opposite. When negotiations of the postsecular are studied in the settings of museums or exhibitions, the aim is not to pinpoint which arguments are informed by religion and which by the secular. Rather, the postsecular has the multilayered purpose of investigating how the two relate to one another, co-exist, and, most importantly, potentially merge into new formations.

Artworks and their display in museums are always a result of negotiations and in themselves constitute such new formations. The postsecular is an invitation to break away from traditional art historical categories in which religion has been parked as logical (primitive, naïve, outsider) and those in which it does not appear to exist at all (fine art). Recent trends in scholarship seem to take up this invitation with the argument that art has the ability to elicit spiritual encounters, or even more fundamentally, is a form of religion itself. Such scholarship approaches art as 'embodied meaning,' as Arthur Danto argued in his last book.[226] If we are to approach art as embodiment and as presence, then artworks in themselves need to be regarded as embodiments of religion, the spiritual, and/or the secular. It is no longer a matter of either one dimension or the other, no longer a comparative or replacement perspective. From the postsecular perspective artworks become intertwined embodiments of meaning.

That which is regarded as sacred, then, is no longer the prerogative of art or heritage connected to a religious institution or tradition. Yet, the non-binary approach endorsed by the postsecular also extends to the sacred. It is an invitation to explore an emancipation of the use of the term 'sacred,' to recognize it outside of the places that are self-evidently religious. In the footsteps of Emile Durkheim, those objects, places, ideas that are set-apart and are invested with non-negotiable, ultimate value, function as sacred.[227] Such emancipation acknowledges the multifaceted presence of the sacred in the arts, invested by artists, conveyed by museums, and attributed by audiences. Therein lies the conceptual potential of the postsecular.

226 Arthur Danto. 2013. *What Art Is* (New Haven: Yale University Press).
227 Lynch, *On the Sacred*; Christopher Partridge. 2013. *The Lyre Of Orpheus: Popular Music, The Sacred, and the Profane* (Oxford: Oxford University Press).

Acknowledgements

I received the invitation to write this essay from editor S. Brent Plate. After meeting Brent at the 2017 meeting of the American Academy of Religion, I sent him a draft research proposal for feedback. Brent responded with this kind invitation. While the proposal made it to the final stage of the national postdoc competition, it was not awarded a grant for a variety of reasons. One of them being uncertainty about the theoretical framework of the postsecular, exactly that aspect Brent had seen as valuable departure point for this contribution to the *Research Perspectives* series. While I shared Brent's immediate inclination about the postsecular's relevance in the study of religion and the arts, I experienced it a challenge to concisely explain it to the grant assessment committee. Writing this essay significantly stimulated my thinking about the postsecular and its analytical potential. I look forward to future fruitful and thought-provoking conversations with colleagues in the study of religion and the arts, regardless of their grant-giving capacities. The first conversation partner was this essay's anonymous reviewer, who highlighted multiple important issues. I have tried to address these in the final text—thank you!

Research I conducted over the last few years has greatly informed the writing of this essay. I am grateful for the support of the Catharina van Tussenbroek Fund and Rocky Mountain College, allowing me to spend a research stay with Aaron Rosen in Billings, Montana during the winter of 2017-18. My contribution to the academic competition of the Teylers Theological Society, themed 'the museum as laboratory in the contemporary quest for God', was awarded the society's golden medal in 2018. Thank you, Marcel Barnard, for launching the competition and the encouragement expressed through this prize. My work on the spiritual in the art and writing of Piet Mondrian was awarded the inaugural postdoctoral award from the Jeffrey Rubinoff Sculpture Park in 2018. Elizabeth Kennedy, James Fox, Karun Koernig and all at the JRSP, many, many thanks—the prize significantly supported the continuation of that research until this day.

I am grateful to the Centre for Religion and Heritage at the University of Groningen, for inviting me in as a fellow. For the ongoing conversation and inspiration regarding the complexities of religion in modern and contemporary art, I want to extend my thanks to the participants in initial meetings of our new Visionary Artists, Visionary Objects (1800-now) research network. The best part of doing research is meeting awesome colleagues and experts along the way. Particularly, my sincere gratitude goes out to Naomi Billingsley, Guido van Hengel, Andrew Irving, Sally Promey, Aaron Rosen, and Todd Weir.

And I thank Erik, to whom this essay is dedicated, for his enduring faith in me.

Bibliography

Abramoviç, Marina; Kaplan, James. 2016. *Walk through Walls, A Memoir* (London: Fig Tree/ Penguin).

Andreopoulos, Andreas. 2000. "The Return of Religion in Contemporary Music," *Literature and Theology* 14.1: 81–95.

Arya, Rina. 2011. "Contemplations of the Spiritual in Visual Art," *Journal for the Study of Spirituality* 1.1: 76–93.

Arya, Rina. 2016. "Reflections on the Spiritual in Rothko," *Religion and the Arts* 20: 315–316.

Asfour, Nana. 2018. "The First Abstract Painter was a Woman," *Paris Review* 12 October. https://www.theparisreview.org/blog/2018/10/12/the-first-abstract-painter-was-a-woman/.

Baneke, Joose (ed.), 1993. *Dutch Art and character: Psychoanalytic perspectives on Bosch, Breugel, Rembrandt, Van Gogh, Mondrian, Willink, Queen Wilhelmina* (Amsterdam: Taylor & Francis).

Barnard, Marcel et al. (eds.), 2014. *Worship in the Network Culture: Liturgical Ritual Studies. Fields and Methods, Concepts and Metaphors* (Leuven: Peeters Publishers).

Bauman, Zygmunt. 2000. *Liquid Modernity* (Cambridge: Polity Press).

Bauman, Zygmunt. 2004. *Identity: Conversations with Benedetto Vecchi* (Cambridge: Polity Press)

Bauman, Zygmunt. 2005. *Liquid Life* (Cambridge: Polity Press).

Bax, Marty. 2006. *Het Web der Schepping, Theosofie en Kunst in Nederland van Lauweriks tot Mondriaan* [The Web of Creation, Theosophy and Art in The Netherlands from Lauweriks to Mondrian] (Nijmegen: Sun Uitgeverij).

Beaumont, Justin et al. (2018). "Reflexive Secularization? Concepts, Processes and Antagonisms of Postsecularity," *European Journal of Social Theory* XX(X): 1–19. DOI: 10.1177/1368431018813769.

Beckford, James A. 2012. "SSSR Presidential Address: Public Religions and the postsecular: Critical Reflections," *Journal for the Scientific Study of Religion* 51.1: 1–19.

Bellah, Robert N. 1967. "Civil Religion in America," *Daedalus, Journal of the American Academy of Arts and Sciences* 96.7: 1–21.

Belting, Hans. 1994 (1990). *Likeness and Presence: A History of the Image before the Era of Art* (Chicago: University of Chicago Press).

Bender, Courtney. 2012. "Things in their Entanglements" in Philip S. Gorski et al. (eds). *The Post-Secular in Question: Religion in Contemporary Society* (New York, London: New York University Press). E-book: Chapter 3.

Berlant, Laurent. 2004. "Critical Inquiry, Affirmative Culture," *Critical Inquiry* 30: 445–51.

Blond, Phillip (ed). 1998. *Post-secular Philosophy: Between Philosophy and Theology* (Abingdon: Routledge).

Bodo, Simona. 2012. "Museums as Intercultural Spaces" in Richard Sandell and Eithne Nightingale (eds). *Museums, Equality, and Social Justice* (New York: Routledge). E- book: Chapter 13.

Branch, Lori. 2017. "What is Postsecularity?," Symposium *Art in a Postsecular Age*, Center for Christianity, Culture, and the Arts, Biola University, La Mirada, CA., 4 March. http://ccca.biola.edu/resources/2017/mar/6/art-postsecular-age/.

Buggeln, Gretchen. 2017. "Museum Architecture and the Sacred: Modes of Engagement" in Gretchen Buggeln et al. (eds). *Religion in Museums. Global and Multidisciplinary Perspectives* (London: Bloomsbury): 11–20.

Buxton, Nicholas. 2013. "Creating the Sacred: Artist as Priest, Priest as Artist" in Rina Arya (ed). *Contemplations of the Spiritual in Art* (Oxford: Peter Lang): 49–68.

Carruthers, Jo; Tate, Andrew (eds). *Spiritual Identities: Literature and the Post- Secular Imagination* (Bern: Peter Lang).

Cheney, Sheldon. 1924. *A Primer of Modern Art* (New York: Boni & Liveright).

Cheney, Sheldon 1934. *Expressionism in Art* (New York: Liveright).

Chin, Karen. 2010. "Seeing Religion with New Eyes at the Asian Civilizations Museum," *Material Religion* 6.2: 192–216.

Choe, Hwasun. 2018. "Tears and Meditation in Exhibition: Healing or Cheating?" ISRLC Conference, Uppsala. 29 September.

Clifton, James. 2014. "Conversations in Museums" in Sally Promey (ed). *Sensational Religion: Sensory Cultures in Material Practice* (New Haven, London: Yale University Press): 205–213.

Cohen-Solal, Annie. 2014 (2013). *Mark Rothko* (Amsterdam: Meulenhoff).

Cotter, Holland. 2010. "700 hour Silent Opera Reaches Finale at MoMA," *New York Times*, 30 May. http://www.nytimes.com/2010/05/31/arts/design/31diva.html.

Daniel-Hughes, Carly. 2018. "Sexy Celibates and unmanly men?" *Immanent Frame*. 19 October. https://tif.ssrc.org/2018/10/19/sexy-celibates-and-unmanly-men/?fbclid=IwAR1wuIum6b0iyUlKnJD5N_7WnrCavMpC9HimyPVAKPND5F2khTNLrKCpwow.

Deicher, Susanne. 1994. "Zuivere Vorm en een Verhaal van Lijden [Pure Form and a Story of Suffering]," *Jong Holland* 4: 6–17.

Deicher, Susanne. 1995. *Piet Mondrian, Protestantismus und Modernität* (Berlin: Reimer Verlag).

Doss, Erika. 2009. "The Next Step?" in James Elkins, David Morgan (eds). *Re-Enchantment* (New York, London: Routledge): 297–301.

Droogers, André. 2012. *Play and Power in Religion: Collected Essays* (Berlin: De Gruyter).

Eagleton, Terry. 2001. "Having one's Kant and Eating It," *London Review of Books* 23.8: 9–10.

Eeden, Frederik van. 1909. "Gezondheid en Verval in Kunst [Health and Decay in Art]," *Op de Hoogte: Maandschrift voor de Huiskamer* 6.2: 79–85.

Eddy, Arthur Jerome. 1914. *Cubists and Post Impressionism* (Chicago: McClurg).

Elkins, James. 2001. *Pictures and Tears: A History of People Who have Cried in Front of Paintings* (New York: Routledge).

Elkins, James. 2004. *On the Strange Place of Religion in Contemporary Art* (New York, London: Routledge).

Elkins, James. 2017. "Art History in a Postsecular Age." Symposium *Art in a Postsecular Age*, Center for Christianity, Culture, and the Arts, Biola University, La Mirada, CA., 4 March. http://ccca.biola.edu/resources/2017/mar/6/art-postsecular-age/.

Elkins, James; Morgan, David (eds). 2009. *Re-Enchantment* (New York, London: Routledge).

Fant, Åke. 1986. "The Case of the Artist Hilma af Klint" in Maurice Tuchman (ed). *The Spiritual in Art: Abstract Painting 1890–1985* (New York: Abeville Press): 155–164.

Farago, Jason. 2015. 'Why museums are the new churches', *BBC Culture*, 16 July. http://www.bbc.com/culture/story/20150716-why-museums-are-the-new-churches.

Farago, Jason. "MoMA Protests Trump Entry Ban by Rehanging Work by Artists from Muslim Nations," *New York Times*, 3 February. https://www.nytimes.com/2017/02/03/arts/design/moma-protests-trump-entry-ban-with-work-by-artists-from-muslim-nations.html.

Freedberg, David. 1989. *The Power of Images: Studies in the History and Theory of Response* (Chicago: University of Chicago Press).

Frissen, Valerie et al. (eds). 2015. *Playful Identities: The Ludification of Digital Media Culture* (Amsterdam: Amsterdam University Press).

Gauchet, Marcel. 1999. *The Disenchantment of the World* (Princeton, NJ: Princeton University Press).

Gay, Peter. 1976. *Art and Act. On Causes in History? Manet, Gropius, Mondrian* (New York, London: Harper and Row).

Giurescu Heller, Ena (ed). 2004. *Reluctant Partners: Art and Religion in Dialogue* (New York: The Gallery at the American Bible Society).

Graham, Gordon. 2007. *The Re-Enchantment of the World: Art versus Religion* (Oxford, New York: Oxford University Press).

Graham, Gordon 2017. *Philosophy, Art and Religion: Understanding Faith and Creativity* (Cambridge, New York: Cambridge University Press). E-book: Chapter 6.

Greenberg, Clement. 1989 (1965). "Avant-Garde and Kitsch" in Clement Greenberg, *Art and Culture, Critical Essays* (Boston: Beacon Press): 3–21.

Habermas, Jürgen. 2008. "Notes on Post-Secular Society," *New Perspectives Quarterly*. Fall: 17–29.

Hearney, Eleanor. 2004. *Postmodern Heretics: The Catholic Imagination in Contemporary Art* (New York: Midmarch Arts Press).

Higgins, Charlotte. 2013. "Vatican goes back to the beginning for first entry at Venice Biennale," *The Guardian* 31 May. https://www.theguardian.com/artanddesign/2013/may/31/vatican-first-entry-venice-biennale.

Huizinga, Johan. 1949. *Homo Ludens: A Study of the Play-Element in Culture* (London: Routledge and Kegan Paul).

James, Martin. 1963–1964. "Mondrian and the Dutch Symbolists," *Art Journal* 23.2: 103–111.

Jenkins, Richard. 2000. "Disenchantment, Enchantment and Re-Enchantment: Max Weber at the Millennium," *Max Weber Studies* 1: 11–32.

Kaginsky, Julia. 2010. "Visitor Viewpoint: MoMA's Mystery Man," Website Museum of Modern Art, 10 May. http://www.moma.org/explore/inside_out/2010/05/10/visitor-viewpoint-momas-mystery-man.

Kant, Immanuel. 1987 (1790). *The Critique of Judgment* (Hackett Publishing: Indianapolis).

Kennedy, Randy. 2015. "Mosque Installed at Venice Biennale tests City's Tolerance," *New York Times*, 6 May. https://www.nytimes.com/2015/05/07/arts/design/mosque-installed-at-venice-biennale-tests-citys-tolerance.html?module=inline.

Kennedy, Randy 2015. "Officials in Venice Challenge Mosque Installation at Biennale," *New York Times*, 8 May. https://www.nytimes.com/2015/05/09/arts/design/officials-in-venice-challenge-mosque-installation-at-biennale.html?module=inline.

Kennedy, Randy 2018. "Police shut down Mosque Installation at Venice Biennale," *New York Times*, 22 May. https://www.nytimes.com/2015/05/23/arts/design/police-shut-down-mosque-installation-at-venice-biennale.html.

Klomp, Mirella; Meulen, Marten van der. 2017. "The Passion as a Ludic Practice—Understanding Public Ritual Performances in Late Modern Society: A Case Study from The Netherlands," *Journal of Contemporary Religion* 32.3: 387–401. DOI: 10.1080/13537903.2017.1362879.

Kosky, Jeffrey L. 2012. *Arts of Wonder, Enchanting Secularity* (Chicago, London: University of Chicago Press).

Kosky, Jeffrey L. 2017. "What is Post-Secularity?" Symposium *Art in a Postsecular Age*, Center for Christianity, Culture, and the Arts, Biola University, La Mirada, CA., 4 March. http://ccca.biola.edu/resources/2017/mar/6/art-postsecular-age/.

Krauss, Rosalind. 1979. "Grids," *October* 9: 50–64.

Kruse, Christiane. 2018. "Offending Pictures. What makes Images Powerful" in Christiane Kruse et al. (eds). 2018. *Taking Offense. Religion, Art, and Visual Culture in Plural Configurations* (Paderborn: Wilhelm Fink):17–58.

Kuspit, Donald. 1994. "Art: Sublimated Expression or Transitional Experience: The Examples of Van Gogh and Mondrian," *Art Criticism* 9.2: 64–80.

Latour, Bruno. 2002. "What is Iconoclash? Or is There a World beyond the Image Wars?" in Peter Weibel and Bruno Latour (eds). *Iconoclash, Beyond the Image-Wars in Science, Religion, and Art* (Karlsruhe, Cambridge: ZKM, MIT Press): 14–37.

Lerner, Loren. 2013. "Introduction: Special Section on Contemporary Art and Religion," *Religion and the Arts* 17: 1–19.

Lynch, Gordon. 2012. *On the Sacred* (Durham: Acumen).

Malik, Kenan. 2009. "The God Wars in Perspective" in Maria Hlavajova, Sven Lütticken, and Jill Winder (eds.). *The Return of Religion and Other Myths. A Critical Reader in Contemporary Art* (Utrecht, Rotterdam: Bak, Post-Editions) 118–136.

Masheck, Joseph. 2018. *Classic Mondrian in Neo-Calvinist View.* The Watson Gordon Lecture 2017 (Edinburgh: National Galleries of Scotland and The University of Edinburgh).

Massumi, Brian. 2002. *Parables for the Virtual: Movement, Affect, Sensations* (Durham: Duke University Press).

McClure, John A. 1997. "Post-Secular Culture: The Return of Religion in Contemporary Theory and Literature," *CrossCurrents* 47.3: 332–347.

McClure, John A. 2007. *Partial Faiths: Postsecular Fiction in the Age of Pynchon and Morrison* (Athens, GA: University of Georgia Press).

Meyer, Birgit. 2008. "Religious Sensations: Why Media, Aesthetics and Power Matter in the Study of Contemporary Religion" in Hent de Vries (ed). *Religion: Beyond a Concept* (New York: Fordham University Press): 704–723.

Molendijk, Arie L. 2011. "In Pursuit of the Postsecular," *International Journal of Philosophy and Theology* 76.2: 100–115. DOI: 10.1080/21692327.2015.1053403.

Mondrian, Piet. 1918. "De Nieuwe Beelding in de Schilderkunst [Neo-Plasticism in the Art of Painting]," *De Stijl* 1.7: 73–77.

Morgan, David. 1997. *Visual Piety: A History and Theory of Popular Religious Images* (Berkeley, Los Angeles, London: University of California Press).

Morgan, David 2005. *The Sacred Gaze: Religious Visual Culture in Theory and Practice* (Berkeley, Los Angeles, London: University of California Press).

Newman, Barnett. 1948. "The Sublime is Now" in Charles Harrison and Paul Wood (eds). 2003 (1992). *Art & Theory 1900–2000. An Anthology of Changing Ideas* (Malden: Blackwell Publishing): 580–582.

Paaschen, Jacqueline van. 2017. *Mondriaan & Steiner: Wegen naar Nieuw Beelding* [Mondrian & Steiner: Paths to Neo-Plasticism] (The Hague: Komma, d'Jonge Hond).

Partridge, Christopher. 2013. *The Lyre Of Orpheus: Popular Music, The Sacred, and the Profane* (Oxford: Oxford University Press).

Paul, Herman. 2017. *Secularisatie: Een Kleine Geschiedenis van een Groot Verhaal* [Secularization: A Small History of a Large Narrative] (Amsterdam: Amsterdam University Press).

Plate, S. Brent. 2007. "From Iconoclash to Iconomash" in: James Elkins and David Morgan (eds). *Re-Enchantment* (New York, London: Routledge): 209–211.

Povoledo, Elisabetta. 2018. "The Most Surprising Entry in Venice's Architecture Biennale? The Vatican's," *New York Times*, 25 May. https://www.nytimes.com/2018/05/25/arts/design/venices-architecture-biennale-the-vatican.html.

Prohl, Inken. 2015. "Aesthetics" in S. Brent Plate (ed). *Key Terms in Material Religion* (London: Bloomsbury Publishing): 10–15.

Promey, Sally. 2003. "The 'Return' of Religion in the Scholarship of American Art," *The Art Bulletin* 85.3: 581–603.

Promey, Sally. 2014. (ed). *Sensational Religion: Sensory Cultures in Material Practice* (New Haven, London: Yale University Press).

Promey, Sally. 2017. "Art History in a Postsecular Age," Symposium *Art in a Postsecular Age*, Center for Christianity, Culture, and the Arts, Biola University, La Mirada, CA., 4 March. http://ccca.biola.edu/resources/2017/mar/6/art-postsecular-age/.

Rabimov, Stephan. 2018. "In Suits We Trust," *Forbes*, 01 October. https://www.forbes.com/sites/stephanrabimov/2018/10/01/in-suit-we-trust-fashion-meets-religion-at-suitsupply/#a2d06f1697ee.

Ravasi, Gianfranco. 2013. "La Santa Sede alla Biennale," in Micol Forti and Pasquale Iacobone. *In Principio. Padiglione della Santa Sede. 55. Esposizione Internationale d'Arte della Biennale di Venezia 2013* (Bologna: FMR-ARTE' spa): 15–28.

Reed, Arden. 2017. *Slow Art: The Experience of Looking, Sacred Images to James Turrell* (Berkeley, Los Angeles, London: University of California Press).

Reeve, John. 2012. "A Question of Faith: The Museum as Spiritual or Secular Space" in Richard Sandell and Eithne Nightingale (eds). *Museums, Equality, and Social Justice* (New York: Routledge). E-book: Chapter 9.

Richter, Gerhard. 2009. *Text. Writings, Interviews and Letters 1961–2007* (London: Thames & Hudson).

Riley II, Charles A. 1998. *The Saints of Modern Art, The Ascetic Ideal in Contemporary Painting, Sculpture, Architecture, Music, Dance, Literature, and Philosophy* (Hanover NH: University Press of New England).

Ringbom, Sixten. 1966. "Art in 'The Epoch of the Great Spiritual:' Occult Elements in the Early Theory of Abstract Painting," *Journal of the Warburg and Courtauld Institutes* 29: 386–418.

Rodman, Selden. 1957. *Conversations with Artists* (New York: Devin-Adair).

Roest, Henk de. 2015. "Lessen van Religies: Jürgen Habermas en de onmisbaarheid van Religieuze Gemeenschappen [Religious Lessons: Jürgen Habermas and the Inevitability of Religious Communities]" in Govert Buijs and Marcel ten Hooven (eds). *Nuchtere Betogen over Religie: Waarheid en Verdichting over de Publieke Rol van Godsdiensten* [Sober Pleas about Religion: Truth and Fiction about the Public Role of Religions] (Budel: Damon): 217–227.

Rosen, Aaron. 2015. *Art + Religion in the 21st Century* (London: Thames & Hudson).

Rosenblum, Robert. 1961. "The Abstract Sublime," *ARTnews* 59.10: 38–41.

Rosenblum, Robert. 1975. *Modern Painting and the Northern Romantic Tradition: Friedrich to Rothko* (New York, Harper and Row).

Schewel, Benjamin. 1997. *Seven Ways of Looking at Religion* (New Haven: Yale University Press).

Schmeets, Hans. 2018. *Wie is religieus en wie niet?* [Who is religious and who is not?]. Report Centraal Bureau voor de Statistiek [Central Bureau for Statistics].

Sharpe, Matthew; Dylan Nickelson (eds). 2014. *Secularisations and their Debates. Perspectives on the Return of Religion in the Contemporary West* (Dordrecht: Springer).

Smallenburg, Sandra. 2017. "Marina Abramoviç, Het interview," *Het Blad bij NRC* 9.

Taves, Ann. 2013. "Building Blocks of Sacralities. A New Basis for Comparison Across Cultures and Religions" in Raymond F. Paloutzian and Crystal Park (eds). *Handbook of Psychology of Religion and Spirituality* (New York, Guilford Press): 138–161.

Terlouw, Kees. 2009. "Rescaling Regional Identities: Communicating Thick and Thin Regional Identities," *Studies in Ethnicity and Nationalism* 9.3: 452–464.

Tuchman, Maurice. 1986. "Hidden Meanings in Abstract Art" in: Maurice Tuchman et al. (eds). *The Spiritual in Art: Abstract Painting 1890–1985* (New York: Abeville Press): 17–61.

Veen, Louis. 2017. *Piet Mondrian, The Complete Writings*. (Leiden: Primavera Press).

Velde, Paola van de. 2018. "Nachtwacht geeft straks alle Geheimen Prijs [Nightwatch to Reveal all Secrets]," *Telegraaf*, 16 October. https://www.telegraaf.nl/nieuws/2685678/nachtwacht-geeft-straks-alle-geheimen-prijs.

Vertovec, Steven. 2006. "Towards post-multiculturalism? Changing Communities, Conditions and Contexts of Diversity," *International Social Science Journal* 64.199: 83–95.

Vries, Hent de. 1999. *Philosophy and the Turn to Religion* (Baltimore: The Johns Hopkins University Press).

Welsh, Robert. 1971. "Mondrian and Theosophy," in *Mondrian. Centennial Exhibition* (New York: Guggenheim Museum): 35–52.

White, Michael. 2006. "Dreaming in the Abstract: Mondrian, Psychoanalysis and Abstract Art in the Netherlands," *Burlington Magazine* 148.1235: 98–106.

Wijnia, Lieke. 2018. "Knowing through Seeing: Piet Mondrian's Visions of the Sacred'. Paper Presentation, Company of Ideas Forum, Jeffrey Rubinoff Sculpture Park, 26 June.

Wijnia, Lieke. Forthcoming. "Piet Mondrian's Abstraction as a Way of Seeing the Sacred" in Louise Child and Aaron Rosen (eds). *Religion and Sight* (Sheffield: Equinox Publishing).

Wolkoff, Julia. 2018. "How the Swedish Mystic Hilma af Klint Invented Abstract Art," *Artsy*, 12 October. https://www.artsy.net/article/artsy-editorial-swedish-mystic-hilma-af-klint-invented-abstract-art.

Zaya, Octavio. 2015. "Are we not all Foreigners?" Website Hayv Kahraman. http://www.hayvkahraman.com/2017/01/21/are-we-not-all-foreigners-octavio-zaya/.

Zonderop, Yvonne. 2018. *Ongelofelijk: Over de Verrassende Comeback van Religie.* [Unbelievable: About the Surprising Comeback of Religion] (Amsterdam: Prometheus).

Printed in the United States
By Bookmasters